DIGITAL LANDSCAPE PHOTOGRAPHY

IN THE FOOTSTEPS OF
ANSEL ADAMS AND
THE GREAT MASTERS

BY MICHAEL FRYE

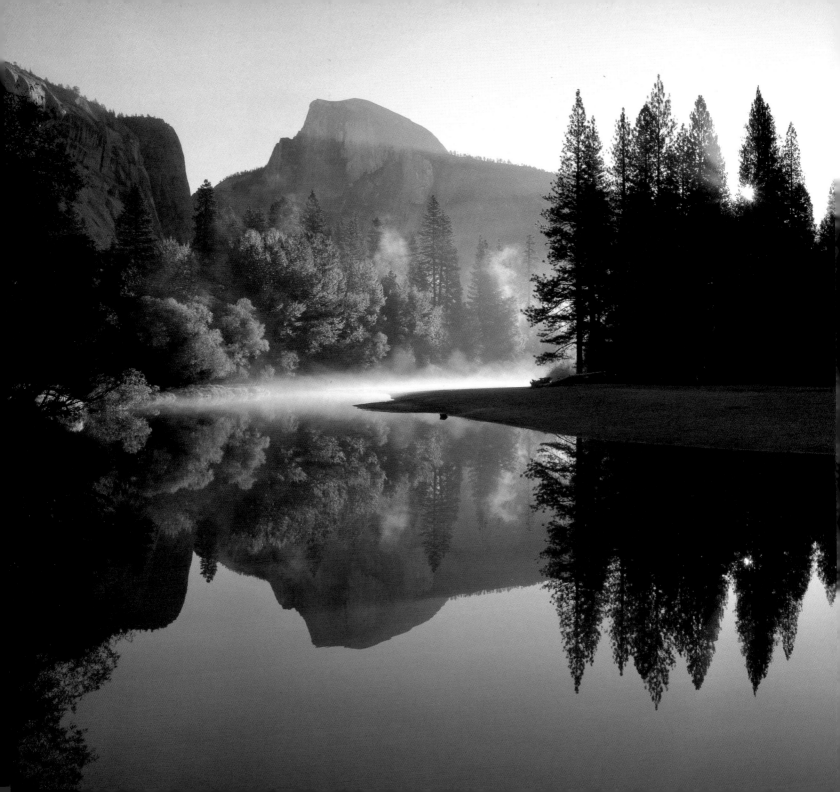

DIGITAL LANDSCAPE PHOTOGRAPHY

IN THE FOOTSTEPS OF
ANSEL ADAMS AND
THE GREAT MASTERS

BY MICHAEL FRYE

ILEX

First published in the United Kingdom
in 2009 by:

I L E X

210 High Street

Lewes

East Sussex

BN7 2NS

www.ilex-press.com

Publisher: Alastair Campbell

Creative Director: Peter Bridgewater

Managing Editor: Chris Gatcum

Commissioning Editor: Adam Juniper

Art Director: Julie Weir

Senior Designer: Emily Harbison

Designer: Richard Wolfströme

British Library Cataloguing-in-Publication Data
A catalogue record for this book is available from the British Library.

ISBN 978-1-905814-75-6

Printed in China

10 9 8 7 6 5 4

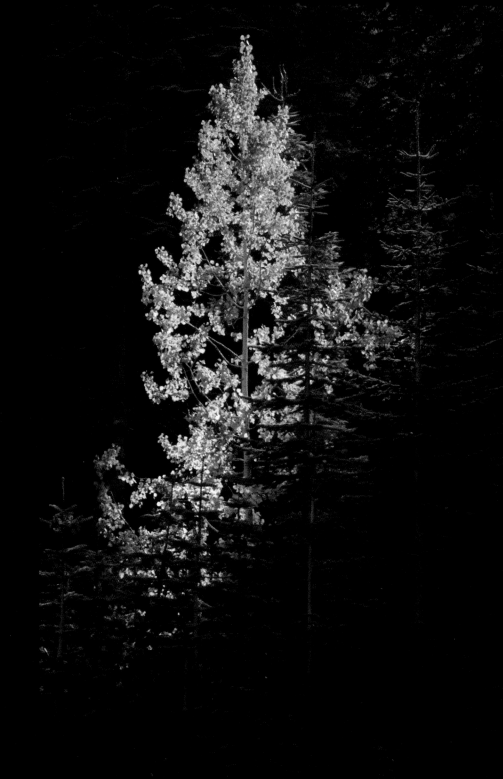

Contents

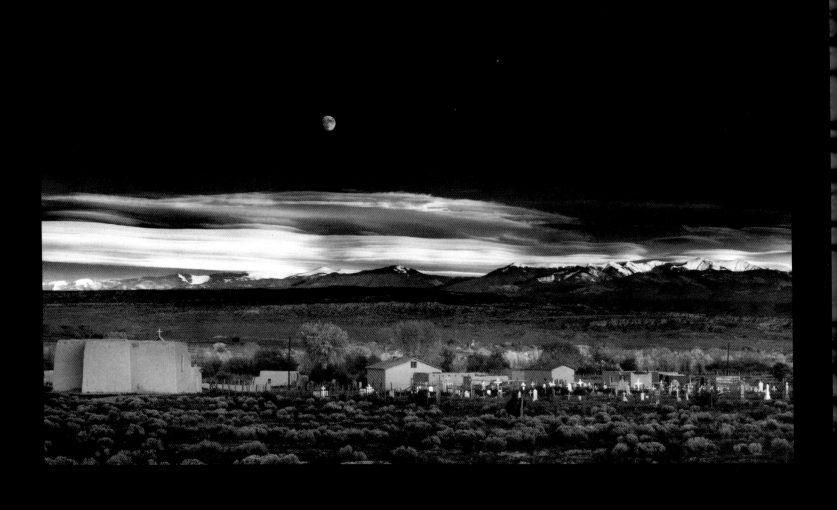

Introduction

This photograph exemplifies Ansel Adams' vision, camera technique, and darkroom mastery. While driving to Santa Fe he glanced to his left and saw what he described as "an inevitable photograph." And while it seemed inevitable to him, how many photographers would have realized the potential of this scene? And how many would have chosen this composition? More than half of this famous image is blank sky. Most people would have used a longer lens and zoomed in on the crosses and moon, but Adams instinctively knew that the expanse of sky would add to the majestic mood of the scene.

Having visualized his image, he encountered a problem: He couldn't find his light meter! Yet he somehow remembered the luminance of the moon in foot candles, and was able to calculate the exposure based on that. His decisions were swift, instinctive, and accurate. Years of experience had made technique second nature to him.

Despite his mostly accurate calculations, the negative proved troublesome. Adams intensified its foreground to increase contrast, and used extensive dodging and burning during printing. In early prints he left the sky light. He gradually darkened it over the years until it became nearly black, enhancing the stark drama of the scene. As new papers and chemicals became available, Adams' interpretation evolved. He always welcomed new tools and the possibilities they offered.

"I am sure the next step will be the electronic image, and I hope I shall live to see it. I trust that the creative eye will continue to function, whatever technological innovations may develop."
—Ansel Adams

When Ansel Adams wrote this, digital photography was in its infancy. Today most photographs are captured on digital sensors, and film consumption has dwindled. In this digital age, do the landscape masters of the past like Adams, Edward Weston, and Eliot Porter still have anything to teach us? Can the lessons they learned through trial and error with film, paper, and chemicals still apply to photographers checking the histogram on their camera's LCD or making a Curves adjustment on their monitor?

The answer is yes. When Ansel Adams developed the Zone System with Fred Archer in 1940, he gave photographers a great tool for controlling their images—but only with black-and-white film, and only with view cameras, where sheets of film could be processed individually. Today any photographer with a digital camera can have even more control—even in color.

Such unprecedented power creates wonderful opportunities, but can also lead to confusion. How do you apply these controls? How far should you go? Do you have to reinvent the wheel, start from scratch? No, because while the tools may be different, the basic principles that Adams, Weston, and Porter developed still apply.

Visualization and Technique

Adams, Weston, and Porter all stressed the importance of visualization—the ability to imagine the final print, and use all the tools at your disposal to achieve that result.

Visualization might seem less important in an age when photographs can viewed an instant after pressing the shutter, but the tremendous control available to digital photographers means that it is more important than ever, because the possibilities are so vast. Do you visualize having highlight and shadow detail in a high-contrast scene? No matter how much contrast you're facing, it's now possible to show detail throughout the image by merging several images together in Photoshop or with HDR (High Dynamic Range) software. But you have to visualize this in advance in order to make several different exposures that will be aligned and exposed correctly. Do you want great depth of field, beyond what your lens is capable of? Again you must foresee this and take several frames focused at varying distances. Unless you have a clear idea in your mind of what you want to achieve, you might forget a vital step in making your image.

Once you've visualized the desired result, you have to be able to execute the necessary steps. Weston said, "One cannot emphasize too greatly the importance of technique, for no matter how fine the innate sensitiveness, without technique, that 'means to an end,' one must continually falter and stumble and perhaps collapse in a mire of unrealized aspirations."

Adams developed the Zone System to deal with the most difficult technical issue in photography—exposure. While the instant feedback from digital cameras has made this problem easier, the Zone System remains the only way to truly understand and master exposure. It also gives us a vital framework for understanding and controlling contrast in our images, and a path to making prints with a full, rich, full range of tones—the range of tones that Adams' prints are so famous for.

El Capitan and the Merced River, Winter, Yosemite National Park

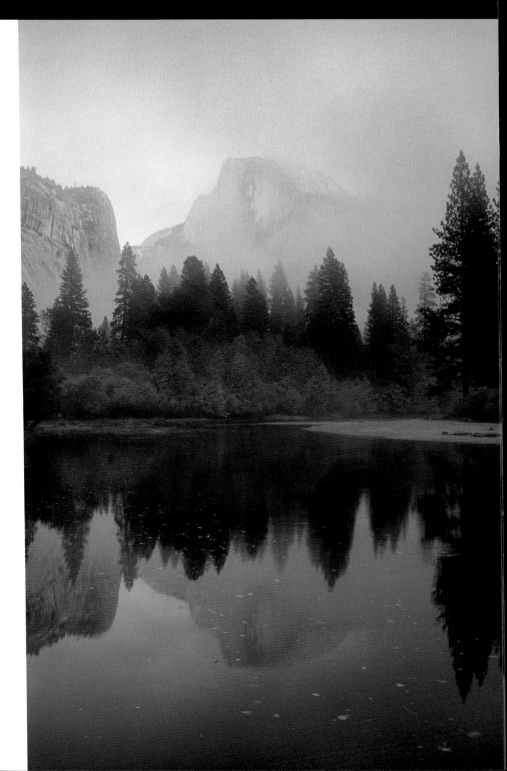

The Art of Seeing

But while technique is important, it is only the foundation. Weston said, "Art is an end in itself, technique a means to that end; one can be taught, the other cannot." He knew that technique served a higher purpose.

And while "Art" may not be teachable, anyone can improve his or her ability to see light and create stronger compositions. By training your eye to see light, color, tones, lines, and shapes, you can hone the visual tools necessary to make expressive photographs.

In this realm, the realm of vision and creativity, nothing has changed. Cameras, whether digital or analog, are just tools. The "creative eye" continues to function, as Adams hoped. In fact digital cameras can be a boost to creativity, allowing experimentation and instant refinement without consulting a film budget.

Ideally your vision and technique work together to create a strong mood. Eliot Porter said, " The essential quality of a photograph is the emotional impact that it carries, which is a measure of the author's success in translating into photographic terms his own emotional response to the subject." It's not enough for a landscape photograph to be pretty. The best photographs evoke a response, a feeling, in the viewer. You must use all the available tools—lines, shapes, colors, tones, exposure, depth of field, and so on—to convey that mood.

Printing and the Digital Darkroom

Making the print is the final, vital step to achieving your vision. Adams said, "I think of the negative as the 'score,' and the print as a 'performance' of that score, which conveys the emotional and aesthetic ideas of the photographer at the time of making the exposure."

Not long ago this performance required having your own well-equipped darkroom, along with many years of trial, error, and experience. Today all you need is a computer and a printer. Yes, experience is still required to make great prints, but the learning curve is less demanding. And while the tools are easier for most people to master, it's judgment and vision that will always separate great prints from mediocre ones. How much contrast is enough? Should there always be areas of black or white in a print? How much saturation is too much? It's here, in developing that judgement and vision, that the past masters have much to teach us.

The Author's Digital Journey

Early in my photography career I used mostly color transparency (slide) film. It was, and still is, a high-contrast, inflexible medium. Printing from transparencies is difficult and offers limited controls. So I and most other color photographers treated the transparency as the final product. The right exposure was the one that looked best on a light box, and a good print simply matched the transparency.

Long before digital cameras were serious tools I started having my film drum-scanned, adjusting those scans in Photoshop, and printing them on some of the earliest digital printers. That process offered much more control and changed my approach. Even with transparency film it became possible to combine several scanned exposures to capture a greater range of contrast. I began to treat the film not as a final product, but as an intermediate step. The important thing was to capture as much highlight and shadow detail as possible, knowing that I could fine-tune the image later.

With digital cameras my approach has evolved further. Even more than with scanned transparencies, I treat the Raw file as just that—raw information. It may take several exposures to capture all the detail in the lightest and darkest parts of the scene. The intended result is visualized in my mind and processed into the finished image. I've been struck by the almost eerie similarity in this new (for me) approach to that used by Adams, Weston, Porter, and other landscape masters of the past. The raw digital file is a like a negative—an intermediate step. The final image may be printed or just viewed on a screen, but either way it's been visualized and interpreted into existence. I have even more control of this interpretation than Adams or Weston had.

It's the dawn of the digital age, and the possibilities are limitless. Armed with modern technology and knowledge from the past, I hope that together we can all take the art of landscape photography to the next level. I trust that our "creative eyes" will continue to function in this digital age, as Adams hoped.

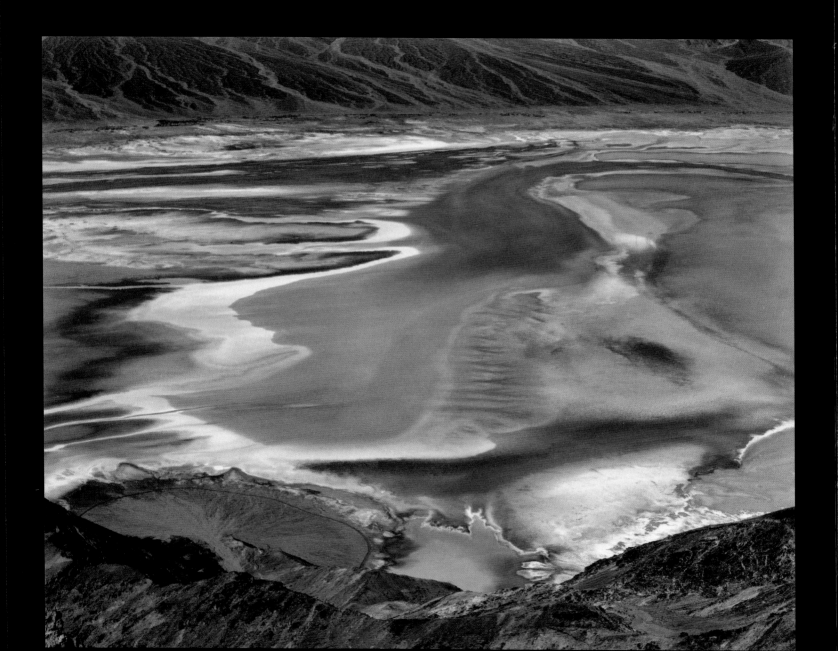

**Dante's View, Death Valley, 1938,
by Edward Weston**

Whether photographing nudes, peppers, or the landscapes of Point Lobos and Death Valley, Edward Weston had a simple, direct, abstract style that has influenced generations of photographers. He strove to capture the essence of his subject, rather than express himself through it: "Without subterfuge, nor evasion, neither in spirit, nor technique, I have recorded the quintessence of the object or element before my lens—rather than an interpretation—a superficial phase, or passing mood."

Sixteen years older than his friend Ansel Adams, Weston learned his craft before Adams codified the Zone System. But he mastered the materials of his era and created a body of prints that are highly valued today, selling at auctions for up to 1.6 million dollars.

Weston knew that good technique was essential: "A photographer perfects his technique for the same reason a pianist practices—that through complete mastery of his chosen tool he may better express what he has to say." But he also knew that technique served a higher purpose: "My work is never intellectual. I never make a negative unless emotionally moved by my subject. And certainly I have no interest in technique for its own sake. Technique is only the means to an end. If my technique is adequate for my seeing, that is enough."

"An excellent conception can be quite obscured by faulty technical execution, or clarified by flawless technique."
—Edward Weston, 1934

Technique is the foundation on which a photograph is built. The most profound visual message will be lost if the image is blurry, or three stops overexposed.

Landscape photography icons like Weston, Eliot Porter, and Ansel Adams were all great artists—men with vision and imagination—but they were also expert craftsmen. By today's standards their equipment and materials were rudimentary, but they mastered them. If they hadn't, their work would have been forgotten long ago.

But is technique as important in the digital age? Can't we just leave the camera on autofocus and program mode? Even if the exposure isn't quite right, or the image isn't quite sharp, can't we just fix that in Photoshop?

Ansel Adams faced the same questions. If the negative isn't perfect, why can't you just fix that in the darkroom? He answered, "We cannot create something from nothing—we cannot correct poor focus, loss of detail, physical blemishes, or unfortunate compositions." Perhaps one thing has changed—a skilled digital retoucher can correct some physical blemishes. But Photoshop does not yet have an "unfortunate composition" filter. There is no software fix for a blurry, out-of-focus image. And while slightly over- or under-exposed originals can be corrected, perfect exposures yield the best results. Adams knew that precise technique at the beginning was the only way to create a beautiful print in the end.

Image Quality

Adams and Weston were founding members of Group ƒ/64. This group reacted to the soft-focus "pictorial" style popular in the 1920s by advocating a pure photographic look. They thought everything in a photograph should be sharp, with great depth of field (hence "ƒ/64," a very small aperture, for the name), and printed on glossy papers to show maximum detail.

To convey this detail, Porter, Adams, and Weston used either 4×5, 5×7, or 8×10 view cameras through most of their careers. Today's digital cameras can render extraordinary detail in smaller packages, but they must be used with care to maximize their capabilities. The modern landscape master Galen Rowell wrote about squeezing as much detail as possible out of his 35 mm camera by using it like a view camera. This meant using a tripod, small apertures for depth of field, and slow, fine-grained film. The same procedures—tripod, small apertures, low ISO—produce great results with today's 35 mm-style DSLRs.

Visualization and the Zone System

Adams wrote, "The term visualization refers to the entire emotional-mental process of creating a photograph, and as such, it is one of the most important concepts in photography. It includes the ability to anticipate a finished image before making the exposure, so that the procedures employed will contribute to achieving the desired result."

For Adams, technique, visualization, and the Zone System were inseparable. He used a spot meter to measure the contrast range of a scene, then exposed and developed the negative to control the values—to increase or decrease contrast. Digital methods are obviously different, but visualization is still vital. It's where imagination meets technique. You conceive the photograph in your mind, then use your best technique to give it life.

Adams' mastery of printing informed the choices he made behind the camera. He knew both the possibilities and limits of his darkroom controls. In the digital age, familiarity with the tools available at the end—Photoshop, HDR software, or other applications—affects how you approach the beginning. As you learn more advanced software techniques, you see new image possibilities, and can then make choices in the field to take advantage of your new skills.

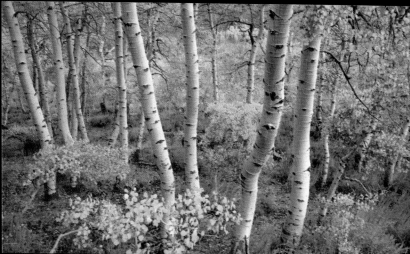

The flat, bluish light from a dusk sky muted the colors and contrast of these aspens, but I visualized a more dynamic photograph. The first image shows the unprocessed Raw file; the second was processed with a warmer color balance, more contrast, and increased saturation.

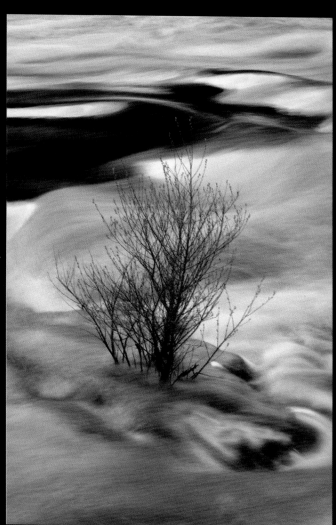

Visualizing Motion

Here I needed to visualize the effect of a slow shutter speed. Experience made it easy to imagine that a long exposure would blur the water, but I also guessed that the smoother water would allow the small shrub to stand out clearly against the background. A digital camera was a great aid, as it showed the effect of blurring the water exactly, and allowed me to fine-tune the shutter speed and composition. Of course, a tripod was essential to keep the bush sharp during the two-second exposure.

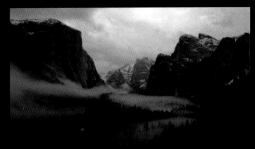

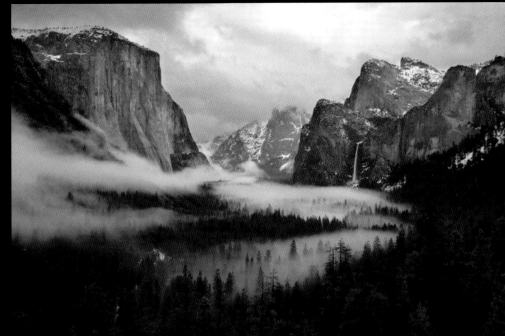

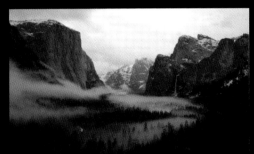

Visualizing Decreased Contrast

This high-contrast scene from Yosemite's Tunnel View required visualizing reduced contrast and a shift in the tonal relationships. Of the three original exposures, each one stop apart, the middle exposure is perhaps the best compromise, but shows washed out highlights in the clouds at the top of the frame, and inky shadows in the trees. I used Photomatix HDR software and Photoshop to blend these images, then converted the composite file to black and white with the digital equivalent of a red filter. The result was a dramatic shift in the tonal relationships: the sky in the final version is much darker relative to the foreground, while the HDR merge created an open, luminous quality to the trees and mist.

Image Quality

Megapixels and Sensor Size

"The kind of equipment used is not what matters. The important thing is that you stay with whatever equipment you choose until it becomes an automatic extension of your own vision, a third eye."
—Edward Weston

Manufacturers love to tout the number of megapixels in their cameras. This is an important consideration for landscape photographers, but not the only one—noise can degrade an otherwise sharp image file. But other things being equal, high-resolution cameras can render finer detail in leaves, pine needles, and grasses.

Resampling a small file will create more pixels, but doing so won't create any more actual image detail. Never throw away pixels needlessly. Always use the highest resolution your camera is capable of, and keep your master files at this resolution (more about master files on page 111).

Noise

Noise is like film grain—a pattern of dots most visible in smooth areas like sky or water. Unlike film grain, noise is not evenly distributed: it's more prominent in shadows. It's also exacerbated by high ISOs and long exposures.

35 mm-style DSLRs come in three main varieties: those with "full-frame" sensors the size of 35 mm film (24×36 mm), and those with sensors about two-thirds that size (around 15×22 mm to 16×24 mm). Full-frame sensors generally show less noise than the two-thirds size sensors, because the individual photosites can be larger, with more light-gathering capacity. But the newest two-thirds size sensors control noise very well, and can produce excellent images.

Serious landscape photographers should also consider a "medium-format" digital camera. These have even larger sensors, from 33×44 mm to 40×54 mm, with high megapixel counts and generally low noise. On the other hand, "point-and-shoot" digital cameras have tiny sensors, and are plagued with noise.

Noise Reduction

First, a sturdy tripod allows you to use low ISOs without worrying about camera shake.

Noise often becomes more visible when trying to lighten dark shadows in software, so the next step to controlling noise is proper exposure, which generally means making the image as light as possible without losing detail in highlights. When a scene has too much contrast to retain both good highlight detail and good shadow detail, it may be necessary to combine two or more images in software.

Many cameras have a noise-reduction setting for long exposures. Using this takes time—after a 30 second exposure, the camera then processes the image for another 30 seconds—and it may or may not help. You have to test your own camera to see if the noise-reduction setting is worth the trouble.

As a last resort, specialized noise-reduction software can help. See more about exposure on page 34, about reducing noise in software on page 120, and about combining multiple images on page 144.

High ISO Noise

Low light required pushing the ISO to 400 to freeze the waterfall's motion. Although the noise was not terrible, I was able to reduce it in software.

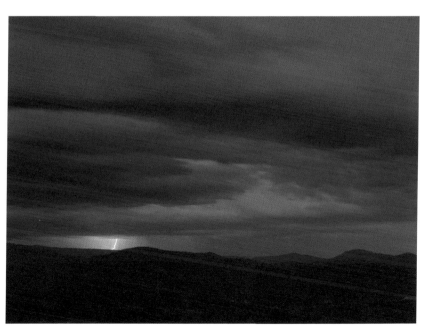

Long-exposure Noise

A long, 15 second exposure at 100 ISO introduced considerable noise, especially in the shadows. Noise reduction software was able to reduce it partially.

Highlight Recovery

A section of the clouds above the mountain El Capitan was washed out, but this was easily fixed with one of the recovery tools available in many Raw processors. The same tools can also work with JPEGs, but because some information has already been discarded, there is less chance of rescuing overexposed highlights like these.

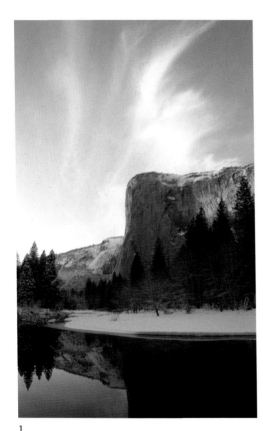

1

2

3

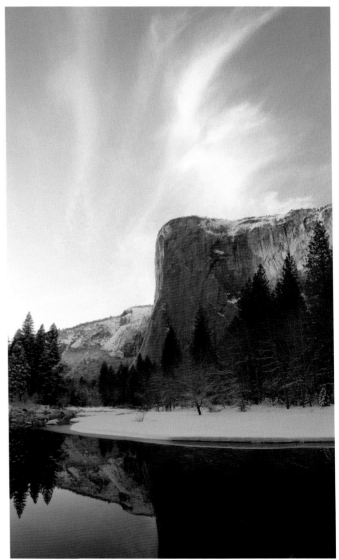

4

1 Original Raw file
2 Close-up of overexposed clouds
 from original file
3 Close-up of recovered highlights
4 Processed Raw file

Camera Settings

Raw versus JPEG

This topic has been hotly debated, with passionate advocates on both sides. The truth is that there are advantages and disadvantages to each mode. JPEGs are Raw files that are processed in the camera and compressed into the JPEG format. Some of the decisions the camera makes in processing the image may be difficult to change later, but the file sizes are much smaller.

Raw

Advantages:

- It's easier to correct exposure mistakes. Overexposed highlights can sometimes be rescued.
- Higher dynamic range (better ability to preserve both highlight and shadow detail).
- White balance corrections are easier.
- Decisions about sharpening, contrast, and saturation can be deferred until the image is processed, then tailored to the individual image.
- All the original image data is preserved
- More color space choices (Adobe RGB, sRGB, etc.).

Disadvantages:

- Larger file size requires more storage space. This includes Compact Flash or SmartMedia cards plus hard drive space.
- Images take longer to write to disk; shorter bursts of continuous shooting.

- Not all programs can read Raw files. This used to be more of a problem, but there are now some excellent applications that work directly with Raw files, such as Adobe's Photoshop Lightroom and Apple's Aperture.

JPEG

Advantages:

- Requires less storage space.
- Images write to disk more quickly; longer bursts of continuous shooting.
- Files can be instantly viewed by many programs, including web browsers, PowerPoint, etc.

Disadvantages:

- Harder to correct exposure mistakes.
- Smaller dynamic range (less ability to preserve both highlight and shadow detail).
- White balance corrections are more difficult.
- Decisions about sharpness, contrast, and saturation are set in the camera, and in some cases may be difficult or impossible to change later.
- Data is thrown out as the image is processed in the camera.
- Fewer color space choices.

JPEGs are like slides or transparencies, and Raw files are like negatives. With JPEGs, most of the decisions about how the image will look are made before the shutter is pressed, and there are fewer options for later changes—just like slides. Raw files always require further processing, and retain more shadow and highlight detail—just like negatives. Raw images can be interpreted in a variety of ways: high contrast, low contrast, high saturation, low saturation, etc.

If Adams, Porter, or Weston were wielding a digital camera today, they would surely all be using Raw mode. These masters of craft would insist on getting the highest quality images, with the most information in the file and the greatest potential for making later adjustments. This applies especially to landscapes, where the ability to write images to disk quickly is less important than when photographing people, sports, or wildlife. Henri Cartier-Bresson might have used JPEG mode, but not Adams.

Many photographers are unnecessarily intimidated by Raw. It's actually easy to use. I always photograph in Raw, even for snapshots or wildlife, as mistakes are easier to correct, and mistakes, especially in exposure, are more common with fast-moving subjects. Two of Raw's biggest disadvantages have almost disappeared: the price of storage media seems to drop daily, and new software makes working directly with Raw files easy. The remaining drawback to Raw is the time it takes to write files to disk. If your camera can capture a burst of 27 images as JPEGs, then the likelyhood is that a burst of Raw is limited to 9. This makes JPEGs a more attractive option files for the serious sport or wildlife photographer, though they must be even more careful with exposure.

Most cameras can capture both Raw and JPEG files simultaneously, but this gobbles even more storage space and further slows writing the files to disk. You're better off picking one or the other. If you choose JPEG mode, make sure you're using the largest file size and highest quality setting. Don't sacrifice any more quality than necessary.

Sharpening

Although you should strive for sharpness in other ways, I recommend applying little or no sharpening in the camera. Oversharpening can create ugly artifacts like halos around edges, and is impossible to fix later in software. It's best to be conservative at the start. With JPEGs, find the menu that deals with sharpening, and use the lowest setting. This option doesn't affect Raw images. With Raw you can decide later, in software, how much initial sharpening to apply.

Contrast

Most cameras have a contrast setting buried deep in the labyrinth of their menus. Again, this option only applies to JPEGs; the contrast for Raw images is set later in software. With JPEGs I recommend using the lowest contrast setting possible. One of the basic rules of digital imaging is that it's easy to increase contrast, but difficult to decrease it. While using a low contrast setting in the camera will make some images look flat, that's easy to fix later, and you'll benefit by getting more highlight and shadow detail in high-contrast scenes.

Even in Raw mode I recommend setting the contrast as low as possible to get the most accurate histograms. The camera's histogram is based on the JPEG preview, so using the lowest contrast setting will make the histogram closer to what the Raw file really looks like. It's worth making some test images using JPEG and Raw simultaneously to compare the contrast and histograms.

1

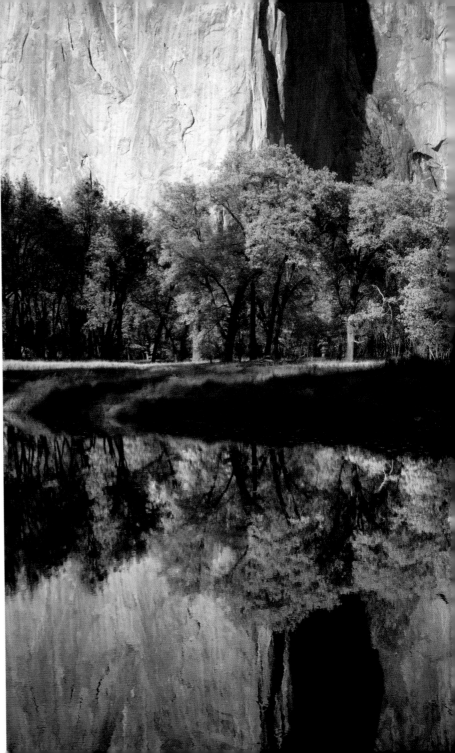

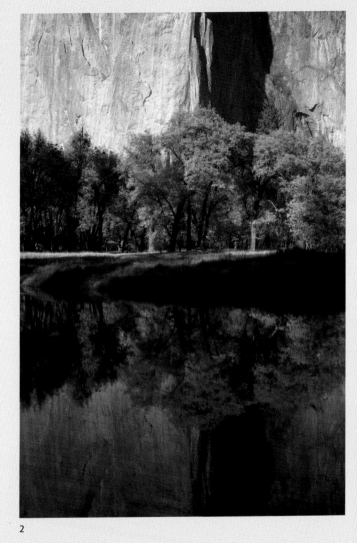

2

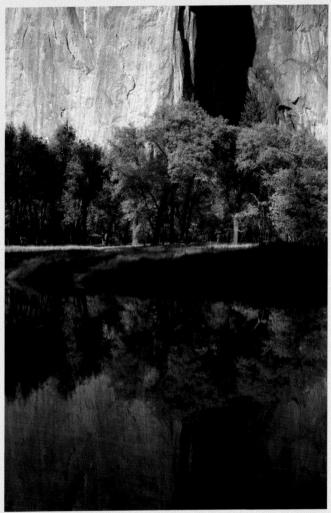

3

1 Processed Raw file
2 Raw original
3 JPEG original

Contrast in Raw and JPEG Files

The original JPEG has more contrast than the Raw file, even though the lowest contrast setting was set in the camera. The shadows in the JPEG are completely black, while there's a hint of detail in the darkest areas of the Raw file. I was able to lighten the bottom part of the Raw image and bring out some of that shadow detail, something that would have been impossible with the JPEG.

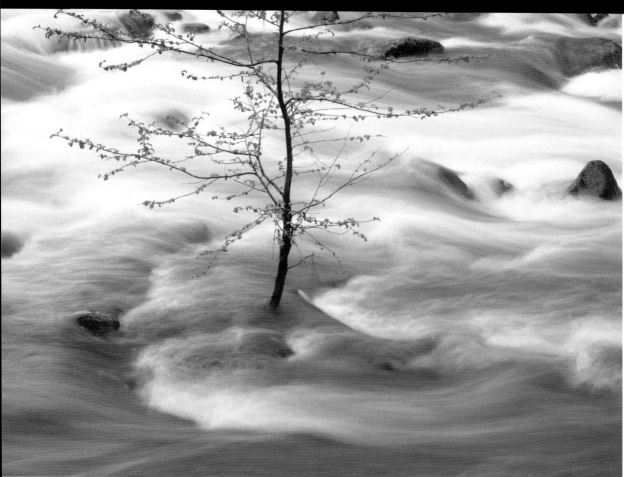

1. **A Stable Platform**
A tripod kept the tree and rocks sharp during the one-second exposure required for this image.

2. **Freezing Motion**
A shutter speed of 1/3000 sec. froze the motion of this hummingbird's wings.

3. **Manual Focus**
If autofocus isn't cooperating, switch to manual focus, as I did with these aspen leaves.

1

Controlling sharpness in the field

Do you want to show every leaf and blade of grass, or deliberately blur the image? The choice is yours—if you're in control. You should be able to render every detail when you need to, and create blurring when it suits you. Sharpness, or the lack of it, is a powerful tool.

You have to learn the rules before you can break them, so you need to learn how to make everything sharp before you can make controlled blurs. We'll start by looking at causes of inadvertent fuzziness and how to avoid them.

Camera Shake

Mix a hand-held camera with a slow shutter speed and you've got a recipe for fuzzy pictures. But there's an easy cure: a tripod. A tripod is as important in landscape photography as a camera or lens. People seem willing to spend thousands of dollars on the latest camera or zoom lens, but then buy the cheapest tripod possible. Get a good one! It should be sturdy, tall enough to reach your eye level, and have easy, intuitive controls. Like any piece of equipment, you must use it to become familiar with it.

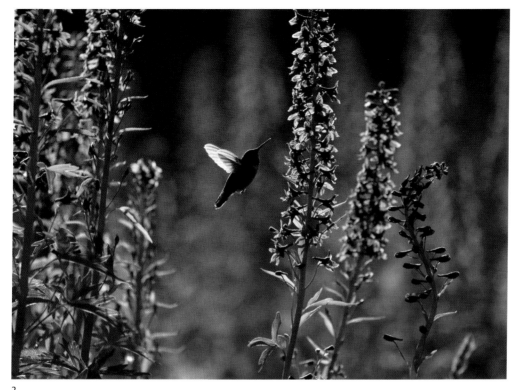

2

3

You should also have a cable release or an electronic release. You can sometimes get away with using the self-timer, but when you set up the tripod for a flower photo, wait ten minutes for the wind to die down, and then it does—but only for one second!—you'll wish you had that cable release.

Subject Movement

Landscapes aren't just made of rocks. You must often deal with flowing water, wind-blown flowers, or waving branches. Freezing motion requires either a fast shutter speed or the patience to wait for the subject to stop moving.

How fast does the shutter speed need to be? It depends on how quickly the subject is moving across the frame. A relatively long exposure can freeze something moving toward you or away from you, but the same object going across the image may need a much faster shutter speed. Experience is the best teacher, but a zoomed-in look at your LCD screen can help.

Focus

Sometimes an image is just out of focus! This can happen when the autofocus locks onto something other than your main subject. Don't be a slave to autofocus—switch to manual when necessary. On the other hand, one of the prime causes of blurry photos is forgetting to switch back to autofocus.

Depth of Field

Simply put, depth-of-field is how much of a photograph is in sharp focus from front to back. Professional photographers understand and use depth of field, while most amateurs don't. Professionals know that they can't leave this critical element to chance, or to the programmed whims of an automatic camera.

Landscape masters Porter, Weston, and Adams always tried to get everything in focus throughout their photographs, to the point of forming Group ƒ/64 in 1932 as mentioned on page 11. Part of their original manifesto read, "The name of this Group is derived from a diaphragm number of the photographic lens.

It signifies to a large extent the qualities of clearness and definition of the photographic image which is an important element in the work of members of this Group."

Modern photography aesthetics accept a wide range of styles, including more impressionistic looks. But emulating Ansel Adams or Edward Weston is never a bad idea. In most landscapes images, everything should be in focus unless there's a specific reason for not doing so—like creating a soft, impressionistic look, or focusing attention on one element.

Factors Affecting Depth of Field

The Lens
Theoretically, a telephoto lens has the same depth of field as a wide-angle lens. This is true if you're talking about subject magnification rather than camera-to-subject distance. But we tend to think in terms of distance rather than magnification. When talking about camera-to-subject distance, wide-angle lenses do provide more depth of field. At ƒ/22 you get from three feet (1 m) to infinity in focus with a 28 mm lens; with a 100 mm lens at the same ƒ-stop you only get from twelve feet (4 m) to infinity.

Shallow Depth of Field

I was able to get most of this coneflower in focus at ƒ/4, and this wide-open aperture blurred the background flowers into blobs of yellow.

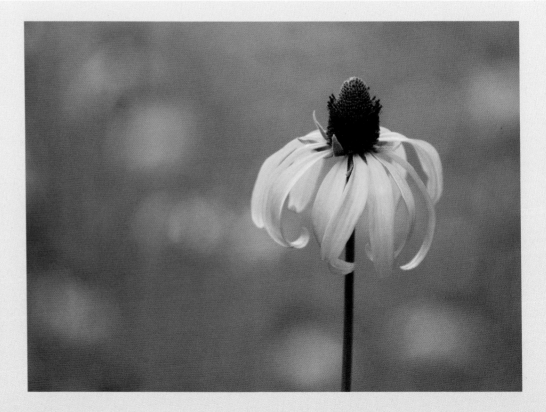

Sensor Size

Most digital SLRs have small, "APS-size" sensors. It's easier to get everything in focus with these cameras because you can use shorter lenses to get the same composition and perspective. With 35 mm film, or a "full-frame" digital sensor, you would need a 32 mm lens to get the same field of view you would get with a 20 mm lens on an APS-size sensor.

Aperture or f-stop

The smaller the aperture, the more depth of field. Is $f/22$ a small aperture or a large one? What about $f/4$? Here's an easy way to remember: the greater the f-stop number, the greater the depth of field; the smaller the f-stop number, the smaller the depth of field. So a large f-stop number, like $f/16$ or $f/22$, means a great depth of field; a small number, like $f/4$ or $f/5.6$, means a shallow depth of field.

If you're mathematically inclined, it might help to know that these numbers are fractions, or ratios. $f/8$ really means focal length in the formula f/D (D being pupil diameter). So, $f/8$ on a 200 mm lens is $200/8 = 25$, so a 25 mm pupil diameter (hole) is required for $f/8$. Similarly on a 20 mm lens, a 2.5 mm pupil diameter would be described as $f/8$. (The pupil diameter and the aperture might not be the same, as many lenses have additional magnifying elements.)

Shallow Depth of Field

Isolating a Subject

- Use a telephoto lens; the longer the better. It's difficult to get everything in focus with a telephoto, but it's easier to throw unwanted things out of focus.

- Use a small f-stop number (large aperture) like $f/4$ or $f/5.6$ (remember, small number, small depth of field).
- Put as much distance as possible between your subject and the background. The more distant the background, the more out of focus it will be.

If that seems easy, it is. But what if you need $f/16$ to get the whole subject in focus yet still want to blur the background? First, take a picture and look at your LCD screen: maybe the background looks okay even at $f/16$. If not, perhaps you don't really need to make the whole flower sharp. An alternative would be to focus just on the most critical parts and leave the aperture wide open (at $f/4$ or $f/5.6$).

Washes of Color

I deliberately put out-of-focus blossoms between the camera and the main subject to create washes of color. The focus point was vital—if only one thing is sharp, it has to be interesting enough to hold the viewer's attention.

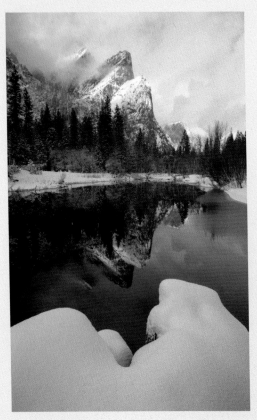

Depth of Field with Wide-Angle Lens

The snow at the bottom of the frame was only two feet from the camera, while the rock formation, Three Brothers, was at infinity. Careful focusing kept everything sharp at $f/22$ with a 24 mm lens on a full-frame sensor.

Great Depth of Field

Getting it All in Focus

Unless you're deliberately trying to isolate one subject, you should get everything in focus. Don't be wishy-washy: either get it all sharp or make just one thing sharp.

How do you get everything in focus?

1) Choose a lens and compose the picture.

2) Focus somewhere between the foreground and background. You'll want to use manual focus for this. Where exactly should you focus? I've heard people say a third of the way between the closest object to the camera and the furthest object. But what's a third of the way between 3 feet and infinity? If you're focused somewhere between the foreground and background, but closer to the foreground, you're close. To be more precise, look through the viewfinder and try to make the nearest and furthest objects equally blurry. To be really precise, follow the steps under "Focusing for Maximum Depth of Field" below.

3) Use a large f-stop number (small aperture) like $f/16$ or $f/22$. With the camera locked on a tripod and a motionless scene you can just use your smallest aperture and hope for the best. But how do you know

if that was enough? Depth-of-field scales have become rare, and depth-of-field previews are hard to use, but all digital cameras have an excellent way to check sharpness: the LCD screen.

Take a picture, then go into playback mode and zoom in. Do the foreground and the background look as sharp as the middle? Make sure you're checking the very closest and furthest objects from the camera. I find it helps to not zoom in too far, otherwise everything looks blurry. Also, use the same magnification each time you check sharpness so you build up a frame of reference.

4) Set the shutter speed. In aperture-priority mode this happens automatically. In manual mode you have to set the shutter speed yourself (see page 34 for more on exposure). If the first image is too light or dark, adjust the shutter speed, but leave the aperture alone to keep everything in focus.

Using a small aperture (large f-stop number) in low light often requires a slow shutter speed. Use a tripod! If you need a fast shutter speed—say you're trying to freeze the motion of a waterfall—you may be able to get everything in focus at $f/8$ or $f/11$ instead of $f/16$ or $f/22$. Alternately, a higher ISO may allow you to use both a small aperture and fast shutter speed.

5) Press the shutter!

Focusing for Maximum Depth of Field

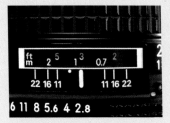

First focus on the object closest to the camera, and note the distance on your focusing ring. In this illustration, it's three feet away.

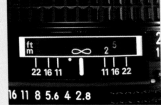

Next, focus on the furthest thing from the camera, and once again check that distance on your focusing ring. Here it's at infinity.

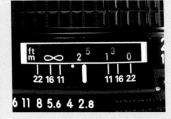

Then set your focus halfway between these two spots on your focusing ring.

Increasing the ISO

This stormy afternoon at Mono Lake required both a fast shutter speed to freeze the motion of the waves and great depth of field. Pushing the ISO to 400 introduced a small amount of noise, but allowed me to shoot at 1/125 sec and f/16.

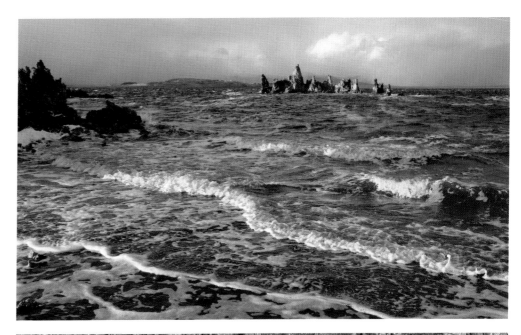

It can be difficult to get enough depth of field with telephoto lenses, especially with larger camera formats. I needed precise focusing and an aperture of f/32 to keep both the redbud and rocks sharp with a medium-format camera (6 × 4.5 cm) and a 150 mm lens.

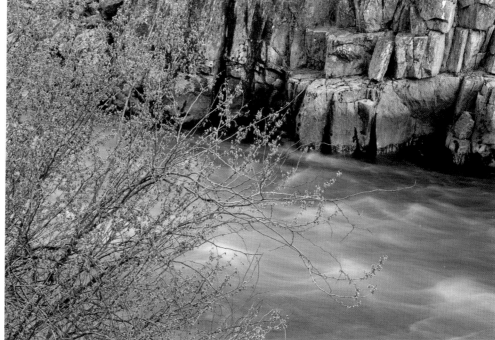

Expanding Depth of Field

Sometimes even your smallest aperture isn't enough
to get everything in focus. Adams, Weston, and Porter
got around this problem by changing the plane of focus
in their view camera. But even without a view camera
it is now possible to expand depth of field by combining
multiple images in software. I explain how to do this
on pages 140-143, but first you have to capture a series
of images in the field that contain all the necessary
information. The area of sharp focus should overlap
between one image and the next, and every part of the
scene must be covered—that is, every part of the frame
should be sharp in at least one image.

I recommend using a medium to small aperture. $f/16$
is a good choice—it's small enough to have some depth,
but not so small as to degrade the image (most lenses
lose some sharpness at their very smallest apertures
due to diffraction).

A tripod is essential to avoid camera movement and
keep the images aligned. Use manual exposure to
ensure consistency between frames. With JPEGs you
should also use manual white balance. Any order will
work, but it helps to be systematic. You could start
by focusing on the foreground, making an exposure,
then focusing a little further back, and so on. Use
the camera's depth-of-field preview or a zoomed-in
look at the LCD screen to make sure that the focus
overlaps between frames.

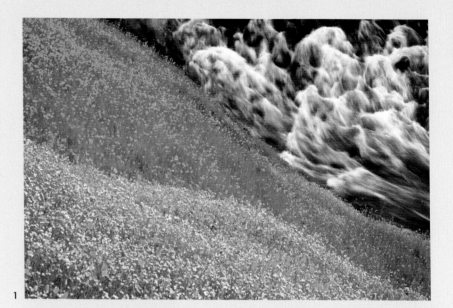

1

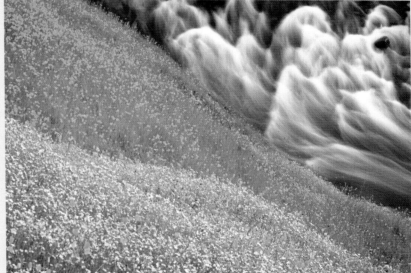

2

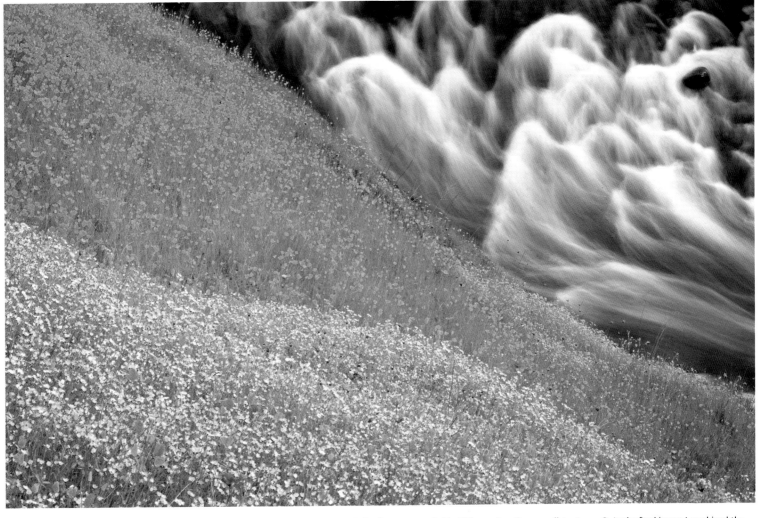

3

**Combining Images
for Depth of Field**

1. I couldn't get enough depth of field for this scene, even at my smallest aperture, so I combined two images. First, I focused on the foreground and pushed the ISO to 400 to get a shutter speed of $1/6$ sec at $f/22$. This allowed me to freeze the motion of the flowers during a lull in the breezy winds.

2. Next I focused on the more distant blossoms and dropped the ISO down to 50. This lengthened the shutter speed to 1½ seconds, long enough to give the water a good silky blur. The flowers remained sharp, despite the slow shutter speed, because their greater distance from the camera made their relative motion slower.

3. In the final image I combined the foreground of the first image with the background of the second. The flowers are sharp throughout, while the water retains its flowing look.

Filters for Black and White

For over a century photographers have used colored filters to alter tonal relationships in black-and-white images. A red filter, for example, makes red objects lighter, but darkens objects that are on the opposite side of the color spectrum, like cyans, greens, and blues. A green filter lightens green objects (or colors close to green, like yellow and cyan), and darkens reds, oranges, and magentas. A classic example is a red apple next to a green apple. In black and white, without a filter, both apples appear medium gray. With a red filter, the red apple becomes light, the green apple dark. With a green filter, the green apple becomes light, the red apple dark.

But in the digital age these filters are obsolete. Converting a color image to black and white in software offers far more sophisticated control. It's like being able to take a paintbrush and change the colors of the scene before applying a filter—to make green trees red, and then put on a red filter. I show how to do this on page 120. So even if you intend to create a black-and-white image, it's better to capture it in full color without filters (except perhaps a polarizer), and convert to black and white later.

In Raw mode you actually have no choice: Raw files are always in full color. If your camera has a menu setting for recording black-and-white images, it only applies to JPEGs. But even in JPEG mode, it's better to keep the images in color until processing. The one case where using the camera's black-and-white mode might be helpful is to better visualize how the scene will look without color. You could try capturing in both Raw and JPEG simultaneously to see the scene in black and white but keep all the color information. Bear in mind that each camera handles this black-and-white conversion differently: some, but not all, make the conversion with the look of a red filter.

1
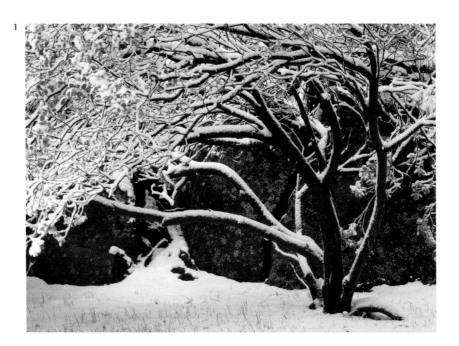

2
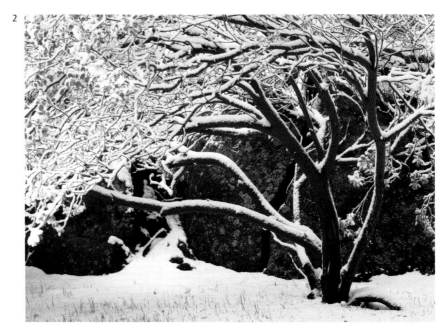

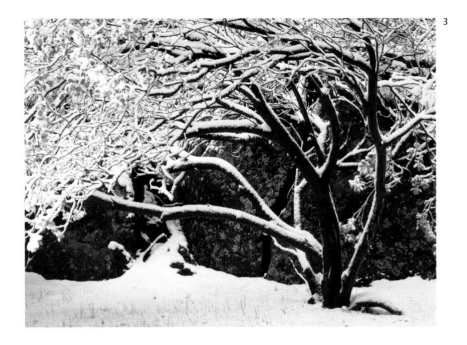

3

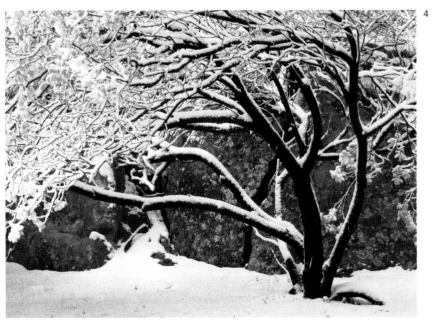

4

Separating Tones

1. This image of a manzanita bush was originally captured in color.

2. A "straight" black-and-white conversion with no filter. The trunk blends into the rock behind it: they're both the same shade of gray.

3. Applying the software equivalent of a green filter didn't help—there's still no separation between the trunk and rock. I tried substitutes for all the traditional filters, but none could separate the tones and make the manzanita stand out.

4. By changing the color of the trunk to magenta in software, and then applying the equivalent of a green filter, I was finally able to make the greenish-yellow rock lighter and the manzanita darker.

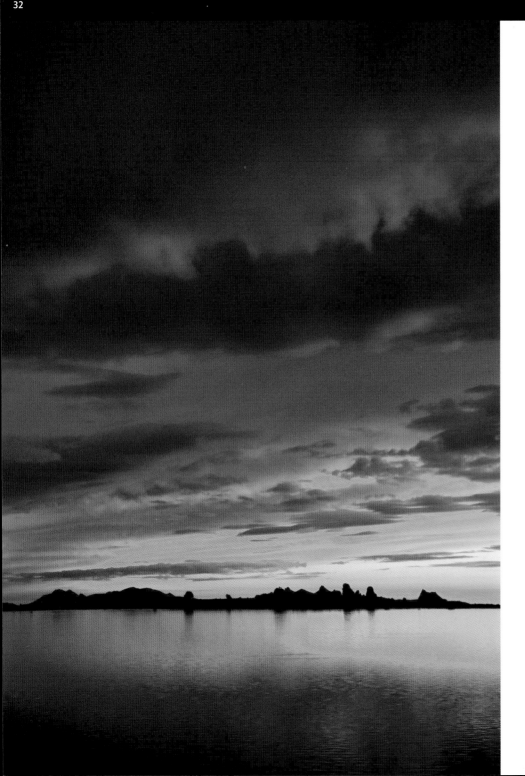

White Balance

For color images, getting the correct white balance is critical—but it doesn't have to be perfect in the camera, as even JPEGs can be adjusted later. Here are a few suggestions for how to deal with white balance:

For Raw images

Just leave the camera set to automatic white balance. This will usually get you close, and then you can fine-tune the color in software (see page 130). If you know the color balance will be tricky, include a white or gray card in one of the frames, then click on that card with an eyedropper tool in software. I always do this at dusk or with mixed lighting (man-made and natural light in the same photograph).

For JPEGs

First, test your camera's automatic white balance in a variety of lighting conditions: sun, shade, overcast, dusk, sunsets, and so on. If it seems to work well—if it's close most of the time—then just leave it set to automatic white balance. You can make minor corrections in your image-editing software.

If the automatic white balance doesn't work well— if it seems to be off much of the time—you're going to have to override it. Set the white balance manually for the conditions. Any scene with at least partial sun, or taken at sunrise or sunset, should be set to daylight white balance.

Sunset Color Temperature

A camera's automatic white balance can easily be confused by sunset colors, but that's easily fixed—just set the white balance to Daylight in the camera, or to around 5000K in software. Daylight, or 5000K, is what slide film is balanced for, and slides handle sunsets very well.

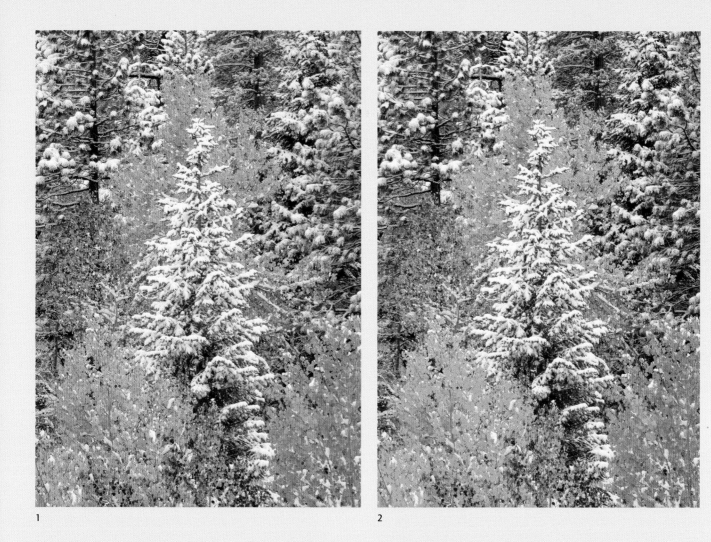

1

2

1 Camera's automatic white balance
2 White balance corrected in software

White Balance for Shade

In dusky shade the camera's automatic white balance chose a color temperature of 4800K for this Raw file—much too blue. The color balance was changed to 7000K using software, making the snow neutral and brightening the colors of the aspens.

Exposure and Histograms

Exposure used to be the single most difficult technical problem in photography, but digital cameras have made this thorny issue much easier. Does that mean you can now just turn on Program mode and turn off your brain? Sorry! Thought and care are still required. The basic problems of exposure have not changed. The only difference is that you can see right away whether you got it right.

Don't judge the exposure by how it looks on your LCD screen. These are notoriously unreliable. They're wonderful for checking compositions, or seeing the effects of a slow shutter speed with a moving subject, but not for judging exposure. There are two good ways to evaluate the exposure of a digital image: a histogram, and a calibrated monitor. Your camera's LCD is not even close to a calibrated monitor, but it does have a histogram.

Most cameras also have an overexposure warning, technically known as the "blinkies." When reviewing an image, overexposed areas will flash, or blink, warning you that these parts of the photograph are overexposed. Since highlights are the most visually important parts of an image—the spots your eyes are drawn to—and since it's difficult to rescue overexposed highlights in software, it's a good idea to pay attention to these warnings. If small, unimportant areas become washed out, that's okay, but critical parts of the scene shouldn't be flashing at you.

But the blinkies only tell you about highlights. A histogram tells you about the whole image if you know how to read it.

Right Edge

The most important part of the histogram is the right-hand edge, because that's where the highlights are. If you see pixels touching the right edge of the histogram, or a spike like this, that means some pixels are overexposed, and parts of the image are washed out.

Left Edge

Pixels pushed up against the left edge of the histogram indicate areas of pure black with no detail.

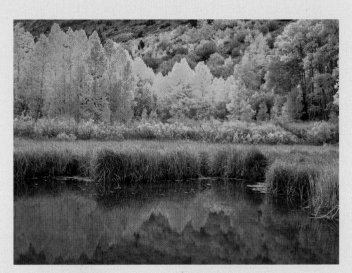

Perfect Exposure

Ideally you'd like to have detail in both the highlights and shadows: nothing washed out, nothing completely black, and a histogram that shows no pixels pushed up against either the right or left edge, as in this photo of Lundy Canyon from the Eastern Sierra.

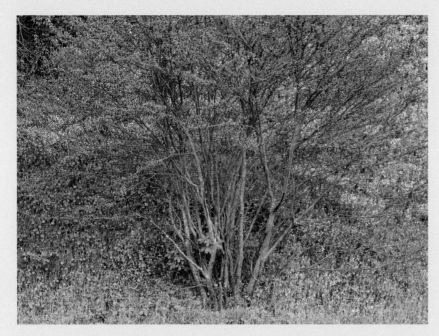

Shape Doesn't Matter

A histogram shows how dark and light pixels are distributed within your photograph. This image of a redbud is low in contrast, with lots of medium tones, so the histogram displays a mound of pixels in the middle. The image of gulls on a pier has no medium tones; it's dominated by the light gold water, with the contrasting dark areas of the gulls and pier. The histogram shows a big spike on the right side—that's the water. There's a smaller spike on the left—the gulls and pier. Both images are properly exposed. The shape of the histogram doesn't matter; these are just different photographs, and the histograms reflect that.

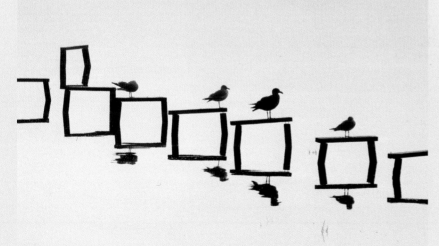

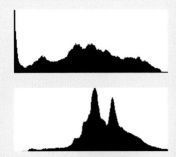

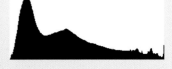

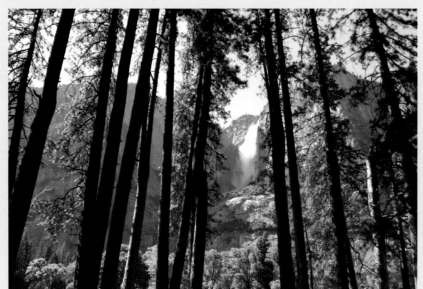

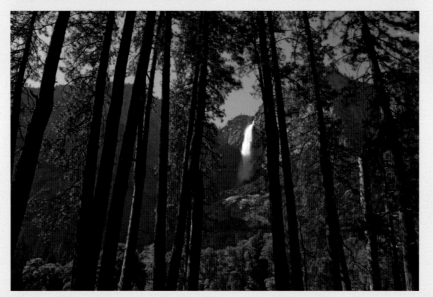

Keep Detail in the Highlights

The first histogram represents an image with black shadows, but detail in the highlights. The second histogram shows a photograph with detail in the shadows, but washed-out highlights. In most landscape photographs bright areas are more important, so it's better to see this first histogram than the second one.

Overexposed High-Contrast Image

The overall exposure for this image of Yosemite Falls is good, but the key highlight, the waterfall, is washed out, as shown by the small spike at the right edge of the histogram.

**Properly Exposed
High-Contrast Image**

This is a better exposure for this scene, as the waterfall is properly exposed—nearly white, but with detail and texture. The sliver of pixels along the bottom near the right side of the histogram represent the waterfall. The left side of the histogram shows that some pixels have gone completely black, but that's preferable to overexposing the most important highlight.

Highlights are Critical

Sunlit snow and dark trunks meant lots of contrast in this image of oak trees. The histogram shows perfectly exposed highlights: pixels near, but not touching, the right edge. Some shadows in the tree trunks have blocked up and become completely black, as shown by the left edge of the histogram, but that's better than seeing washed-out highlights, and actually the small areas of black add impact.

Which Are More Important, Highlights or Shadows?

Often a scene has too much contrast to retain detail in both highlights and shadows. Then you have to choose: Would you rather have detail in the highlights, and let some shadows go black? Or would you prefer to keep detail in the shadows, and allow the highlights to wash out?

The answer depends on the image. Which are more critical, the highlights or shadows? In most landscape photographs, the highlights are more important. Why? First, our eyes are drawn to bright areas, so viewers immediately notice if they're overexposed. Second, in real life we can always see detail in bright spots (except when looking at the sun itself, or the sun reflected in water or glass), but we can't always see detail in shadows. It seems unnatural to find washed out highlights in a photograph, yet it feels perfectly normal to see regions of pure black.

So if you can't have both, 99 percent of the time you should sacrifice the shadows and keep the highlights. In most photographs, the lightest pixels should be close to the right edge, but not touching it. Since digital images actually have more information in lighter tones, you want the image to be as light as possible without being overexposed.

If you really need detail in both highlights and shadows, it's now possible to combine several exposures together in Photoshop or HDR software, which will be discussed later in the book.

1

Exposure Compensation

With practice you can predict which images need exposure compensation and dial it in right away.

1. If the image is predominantly light, as with this snow-covered oak, you'll need plus compensation (start with +1.0).

2. A predominantly dark scene, like this image of a sunlit aspen surrounded by dark fir trees, requires minus compensation (try -1.0 to start, then adjust from there).

Exposure With Digital Cameras

Metering

Most cameras have three metering modes: center-weighted, spot, and a programmed mode called Evaluative (for Canon), Matrix (Nikon), or some other name. The programmed modes "evaluate" the light and dark areas of the image to achieve, in theory, more accurate exposures.

Exposures with center-weighted, Matrix, or Evaluative metering tend to fall in the middle, between the lightest and darkest parts of a scene, since these methods average the all tones together. This works fine when contrast is low, but with high-contrast images the highlights are usually so much brighter than the average exposure that they become washed out. Spot metering can avoid these problems by measuring only a small portion of the scene, but only if you know what you're doing—which means using the Zone System.

In conjunction with histograms, any of these metering modes can lead to perfect exposures with digital cameras. For landscape images, there are three viable approaches: aperture-priority automatic with exposure compensation, manual with center-weighted metering, and the Zone System with spot metering. The choice depends on the subject and your level of experience.

As well as the histogram, most cameras have the option to indicate clipped areas of the image on-screen. This is typically done with a blinking color overlay many photographers refer to as the "blinkies."

Aperture-Priority Automatic with Exposure Compensation

Since aperture-priority mode allows you to control depth of field, it's a better automatic-exposure choice for landscape photography than program or shutter-priority modes. Use either center-weighted, Evaluative, or Matrix metering, then start by choosing the aperture (f-stop). As explained earlier on page 22, use a small aperture ($f/16$ or $f/22$) to get everything in focus, and a large aperture ($f/2.8$ or $f/4$) to isolate your subject and throw the background out of focus. The camera will automatically set the shutter speed. Note that small apertures may result in slow shutter speeds, so use a tripod.

Then take a picture and look at the histogram. In most situations this will look fine. Great—you're done! But if the histogram is shoved too far left or right, use the exposure-compensation dial. If the first image is overexposed—you see pixels pushed up against the right side of the histogram, or you see the "blinkies"—you'll have to dial in "minus" compensation. Try 1.0 to start with. If the image looks underexposed—perhaps you see pixels pushed up against the left edge of the histogram, but there's plenty of room on the right side—you should dial in "plus" compensation. Try +1.0 at first, and keep making adjustments until you get it right. When you're done, be sure to set the exposure compensation back to zero!

2

What About Bracketing?

Many photographers think that bracketing will solve all their exposure problems. But this scattershot method can still completely miss the mark. I've found many situations where the camera's meter indicated an exposure two or three stops lighter than the correct one. So with three bracketed shots, each one stop apart, the darkest image would still be too light. If you bracket, you must still check the histograms and make sure that at least one image is exposed correctly.

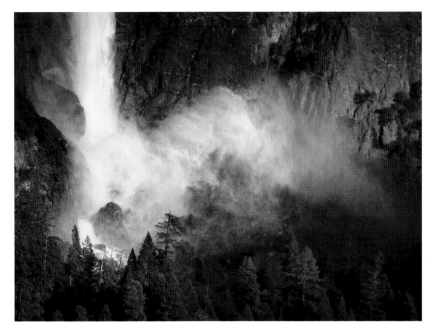

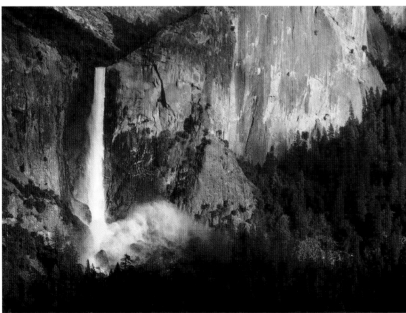

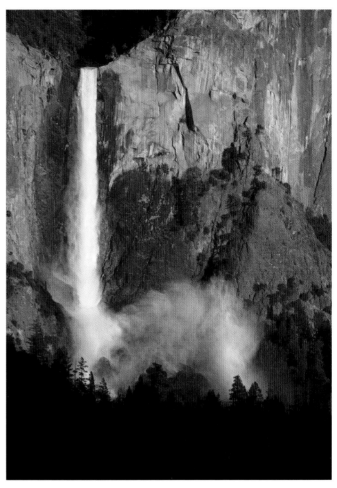

Consistency with Manual Exposures

I manually set an exposure of 1/125 sec at ƒ/5.6 (with a polarizer at 100 ISO) for this sequence of Bridalveil Fall. I knew that as long as the light didn't change, and all the photographs included the same highlight—the waterfall—then the exposure would remain the same. This allowed me to concentrate on composition and timing without thinking about camera settings. Any automatic mode would have required continually adjusting the exposure compensation dial as I zoomed in and out. For the close-up of the base of the fall I might have needed plus compensation, as the frame is predominantly light, while the large dark area at the bottom of the vertical image might have led the camera's meter to overexpose the picture, requiring minus compensation.

Manual Exposure with
Center-Weighted Metering

Set your camera to manual mode and use either center-weighted, Matrix, or Evaluative metering. As with aperture-priority automatic, you should set the f-stop first to control depth of field. Once again, use a small aperture ($f/16$ or $f/22$) to get everything in focus, a large aperture ($f/2.8$ or $f/4$) to isolate your subject and throw the background out of focus.

Next, set the shutter speed. Most cameras have a scale indicating over- or underexposure. Just rotate the shutter speed dial until the scale shows zero. If the shutter speed ends up being slow, use a tripod.

Then take a picture and look at the histogram. Again, in most cases the histogram will look fine. But if the histogram indicates over- or underexposure, or if you see the "blinkies," you'll have to adjust the shutter speed. Don't change the aperture—you already chose this based on depth of field.

If the first image is too light—you see pixels pushed up against the right side of the histogram, or the "blinkies"—use a faster shutter speed. If you started with 1/125 sec, for example, go to 1/250 sec (a faster shutter speed means less light reaching the sensor, a darker image, and, you hope, a better histogram). If the image looks too dark—perhaps you see pixels touching the left edge of the histogram, but there's plenty of room on the right side—use a slower shutter speed. If you started with 1/125 sec, go to 1/60 sec. Keep adjusting the shutter speed until you're satisfied.

Both of these approaches—aperture priority and manual—are similar. If so, is there any reason to use manual mode? Yes! First, when using aperture priority (or any automatic mode), most cameras only allow exposure compensation up to two stops. Sometimes this is not enough, and the only solution is to switch to manual.

Second, manual mode ensures consistent exposures for different compositions of the same scene. With automatic modes, the exposure changes as you move the camera because the meter reads different areas of light and dark. In a wider view, the image might be evenly balanced between sun and shade, while a tighter composition might be mostly shade, causing the camera to lighten the exposure to "compensate" for the dark scene. But if the light hasn't changed, the exposure shouldn't either! Manual mode can eliminate a lot of fiddling with the exposure-compensation dial.

Manual settings are also essential for stitching together panoramas or expanding depth of field by combining multiple images in software. In both cases it's vital to maintain consistent exposures between images.

The Zone System

In 1940, Ansel Adams, along with his fellow instructor at the Art Center School in Los Angeles, Fred Archer, developed the Zone System. Photographers had long known that they could alter the contrast of a negative by changing the development time: shorter development lowers contrast; longer development raises contrast. Adams and Archer were the first to quantify this and relate it to exposure. They created a precise procedure for evaluating the light and dark values of a scene, visualizing the finished photograph, exposing the negative, and developing that negative to hold the contrast the photographer visualized.

This system is still perfectly valid when using black-and-white film today, but how does it relate to digital photography? There's a fundamental rule in digital imaging: it's easy to increase contrast, but difficult or impossible to decrease it. So, if an image looks too flat, it's easy to add more punch later in software. But if the scene has too much contrast—if it exceeds the dynamic range of the camera—then part of the image will either become pure black or pure white.

If you need detail in both highlights and shadows in a high-contrast scene, you're not totally out of luck. Later, on page 50, we'll examine some methods of combining two or more separate exposures to expand the dynamic range. But for now let's assume that your contrast range is fixed. Is the Zone System still useful? Yes, as a way of setting your exposure quickly and accurately. The exposure methods I've described so far involve some trial and error. The Zone System will lead you to the perfect exposure more quickly. With practice you should get the right exposure on your first try at least 90 percent of the time.

To use the Zone System you have to have a spot meter and use the camera in manual mode. The spot meter can be hand-held or built into the camera, but either way, the smaller the spot, the better.

The Zones

Adams and Archer's original Zone System had eleven zones, zero through ten, but with digital cameras we are mostly concerned with zones three through seven. Looking at the accompanying chart, start in the middle at Zone 5. This represents a mid-tone in the scene. Anything one stop darker would render as Zone 4, two stops darker Zone 3, and so on. Anything one stop lighter is Zone 6, two stops lighter Zone 7, etc. Anything at Zone 2—three stops below middle—is too dark to show detail, while Zone 3, although dark, has detail. Anything at Zone 8—three stops above middle—is too light to show good detail, while Zone 7, although light, has detail.

For color photographs you must consider color, not just detail. A light color will lose saturation beyond Zone 6. Although it will still have detail at Zone 7, the color will be pale. And a dark color can't go below Zone 4 without becoming muddy.

"I have found that the Zone System is invaluable in color photography, primarily in relation to exposure, but of course its application poses very subtle considerations."
—Ansel Adams

Zones and Histograms

This diagram shows approximately how each zone relates to a histogram. Pixels pushed up against either the right or left edge indicate that parts of the image are beyond the range of the histogram. The spike at the right-hand edge of this histogram indicates pixels that are overexposed— Zone 8 or higher. Overexposed pixels like this are the main thing to look out for and avoid when judging exposure with a histogram. Anything at the far left edge of the histogram is Zone 2 or lower—black.

Zone 0
Pure black

Zone 1
Nearly black

Zone 2
A hint of detail

Zone 3
Dark, with good detail but muddy color

Zone 4
Dark tone or color

Zone 5
Middle tone, medium color

Zone 6
Light tone or pastel color

Zone 7
Light, with texture but faded color

Zone 8
A hint of detail, but essentially washed out

Zone 9
Nearly white

Zone 10
Paper white

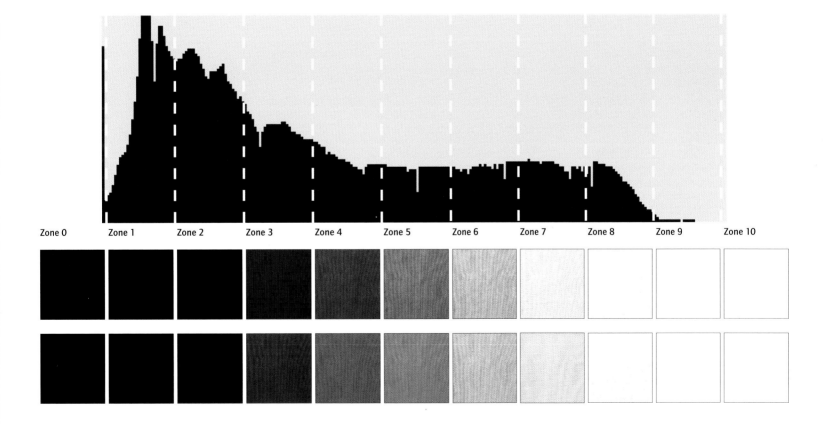

Zone 0 Zone 1 Zone 2 Zone 3 Zone 4 Zone 5 Zone 6 Zone 7 Zone 8 Zone 9 Zone 10

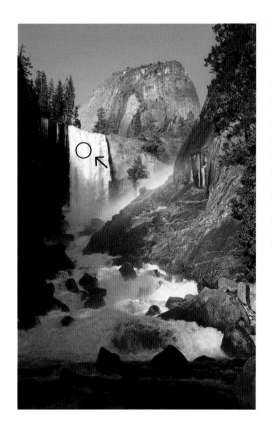

White Subject

The sunlit waterfall is clearly the most important highlight in this photograph. A spot meter reading off the white water indicated 1/125 sec at ƒ/11. Anything white or nearly white, like this waterfall, is a perfect candidate for Zone 7, so I opened the aperture two stops to ƒ/5.6, placing the water on Zone 7—light, but not washed out. (An in-camera spot meter should indicate +2, or two stops of overexposure, for Zone 7, as shown here.) Note that because I wanted to freeze the motion of the waterfall, and depth of field was not a concern, I left shutter speed high and changed the aperture instead.

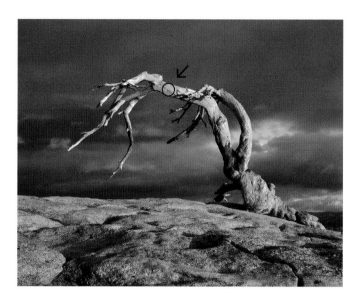

Light Color

The most important highlights here are the lighter tones of the tree. The very brightest spots were too small to meter, but the circled area looked like a perfect Zone 6. The meter indicated 1/15 sec at ƒ/16, so I slowed the shutter speed to 1/8 sec to place the tree at Zone 6. (An in-camera spot meter should indicate +1, or one stop of overexposure, for Zone 6.) Here the subject was still, the camera was on a tripod, and I needed to keep everything in focus, so I kept the aperture at ƒ/16 for depth of field and changed the shutter speed.

The Zone System for Digital Cameras

The simplest approach to the Zone System concentrates on highlights and ignores shadows. Start by picking the most important highlight—not a tiny spot, nor something that lacks detail. Pick the brightest significant part of the scene that needs to have detail and texture.

Then decide what zone that highlight should be. If that sounds hard, it's not, because there are only two choices. Zone 5 isn't a highlight, it's a midtone. Zone 8 is washed out—too light for an important highlight. So that leaves Zone 6 or Zone 7. Use Zone 7 for objects that are white or nearly white, like white water, snow, light sand, or very light rock. Use Zone 6 for any other highlight, including tans,

yellows, light greens, or something that you would describe as a light or pastel color.

Next, take a spot meter reading from the highlight you've picked. Make sure the whole spot is filled with a consistent tone; you don't want a mixture of light and dark areas. A very small, narrow-angle spot meter is invaluable. If you're using your camera's built-in meter, try zooming in or changing to a longer lens. When using a hand-held meter make sure you compensate for filters. Add one-and-a-half to two stops of light for a polarizer, or hold the filter up against the meter and take readings right through it.

To make the highlight Zone 6, increase the exposure by one stop from your meter reading. To make it

Zone 7, increase the exposure by two stops. If you don't do this—if you just use the meter's recommended settings—the highlight will render as a middle tone, or Zone 5. So you need to lighten the image to make that highlight Zone 6 or Zone 7. For example, if the meter indicates 1/125 sec at ƒ/16, lower the shutter speed to 1/60 sec to make that highlight Zone 6, or 1/30 sec to make it Zone 7.

You actually don't need to make these calculations with an in-camera spot meter. While pointing the meter at the highlight, just turn either the shutter speed or aperture dial until the exposure scale indicates two stops of overexposure for Zone 7, or one stop of overexposure for Zone 6.

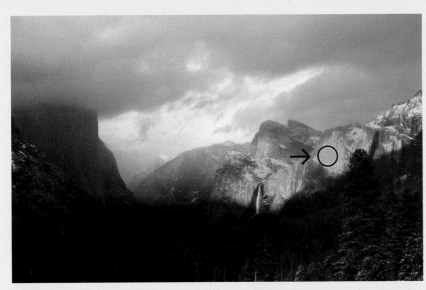

Sunset Color

The golden cliffs are not the brightest things in this photograph, but they are clearly the focal point. Sunrise or sunset color on mountains should almost always be placed at Zone 6. After making an exposure I checked the histogram to make sure that the white clouds weren't overexposed.

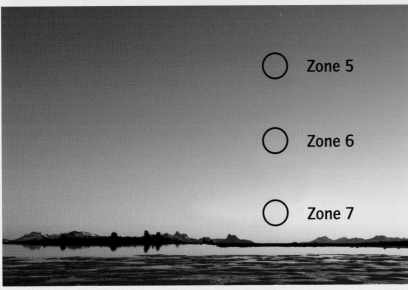

Small Highlight

If the highlights are too small to meter, see if you can move in closer. Here the critical highlights were the white flowers. Even with a one-degree spot meter I couldn't fill the spot's circle with just one blossom from the camera position, but it was easy to move in closer and meter off just one petal, then place that white subject on Zone 7.

Sky

It's difficult to meter skies because they vary so much. Near the horizon, a dusk sky like this should usually be placed on Zone 7; higher up it becomes Zone 6, Zone 5, or lower.

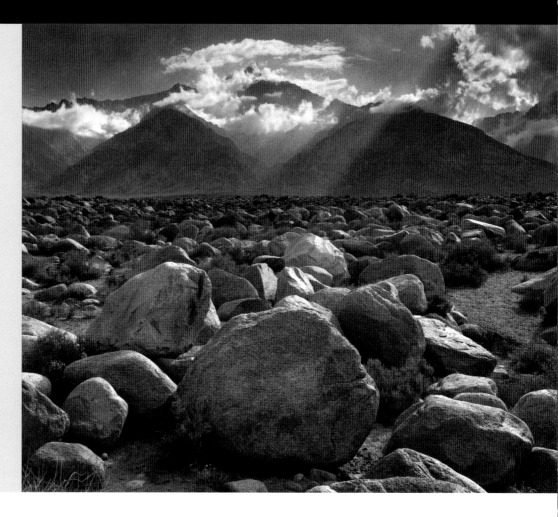

Mt. Williamson, Sierra Nevada, from Manzanar, California, 1945 by Ansel Adams

These mountains, lit from behind, form almost abstract shapes, much like Minor White's famous Grand Tentons (1959) image. There is a strong emotional and even spiritual quality in evidence in this shot.

Expanding and Contracting the Contrast Range

Minor White began teaching with Ansel Adams at the California School of Fine Arts in San Francisco in 1946. When Adams explained the theory of the Zone System to him he thought, "Why didn't I think of that?—It's so easy! And so that afternoon I started explaining the Zone System to people."

He went on to teach the Zone System to generations of photographers in San Francisco, at the Rochester Institute of Technology, and MIT. His students included Paul Caponigro and Jerry Uelsmann. He combined the practical techniques of the Zone System with meditation and hypnosis to help his students "see."

The heart of the traditional Zone System is the ability to expand or contract the contrast range of the negative—to increase contrast and add impact to flat, low-contrast images, or reduce contrast to hold detail in both highlights and shadows in high-contrast scenes.

With black-and-white film, the Zone System mantra is, "Expose for the shadows, develop for the highlights." In other words, after determining the correct exposure for the most important shadows, you develop the negative

Effect of Expansions

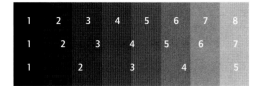

Normal development

N + 1 development

N + 3 development

Effect of Contractions

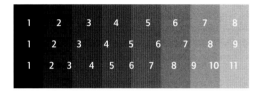

Normal development

N − 1 development

N − 3 development

An Adaptation of Minor White's Diagram for Expansion and Contraction in the Zone System

Increasing contrast with levels or curves

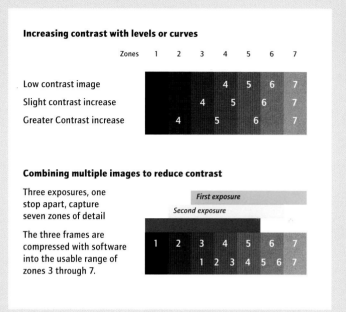

Low contrast image

Slight contrast increase

Greater Contrast increase

Combining multiple images to reduce contrast

Three exposures, one stop apart, capture seven zones of detail

The three frames are compressed with software into the usable range of zones 3 through 7.

Expansion and Contraction for Digital Cameras

to control how light the brightest highlights are. Reduced (minus) development will bring highlights that would otherwise be overexposed down into usable territory like Zone 7. Increased (plus) development will push a dull highlight that would normally be at Zone 5 or 6 into the more brilliant range of Zone 7 or 8. Shadows are relatively unaffected by changes in development.

The first diagram (above, left) was adapted from one created by Minor White as an aid for teaching the Zone System. The diagram shows the effects of contraction—reducing contrast through less-than-normal

development—and expansion—increasing contrast through greater-than-normal development. Contraction brings areas that would normally be Zone 9, 10, or 11 down to Zones 7 and 8. Expansion pushes objects that would normally fall at 5, 6, or 7 up to Zone 7 or 8.

Digital cameras require the opposite approach: exposing for the highlights and developing for the shadows. "Developing" in this case means either increasing contrast with curves or levels, or decreasing contrast by combining exposures with Photoshop or HDR software. The second diagram adjusts White's concepts for digital cameras.

Using the Zone System to Combine Multiple Images

First, make sure the camera is on a sturdy tripod to avoid camera movement between frames.

Then, start by spot-metering the brightest highlight. Place this at Zone 7 (overexpose by two stops from the indicated meter reading). Take the picture and check the histogram. The brightest pixels should be near, but not touching, the right edge of the histogram. If not, adjust either the shutter speed or aperture until the histogram looks right.

Then check the left edge of the histogram. If no pixels are pushed up against the left edge, that means you have detail in the shadows, and you don't need to do anything else. But we'll assume that this is a high-contrast scene, and that some pixels are touching the left edge. You could now spot meter the darkest shadows to determine how much darker they are than the highlights. But it's simpler to just make another exposure one stop lighter than the first one, and check the histogram again. If you still see blocked shadows, make another exposure one stop lighter, and another, and so on, until you see space between the darkest pixels and the left edge of the histogram. You've then captured detail in both highlights and shadows, plus a full range of tones in between.

You could use 1⅓ stop intervals, or 1½ stops. Two stops is probably too far apart; the ideal interval between exposures for an HDR merge is usually between 1 and 1½ stops.

Auto-bracketing is usually too scattershot to be a serious tool, but when combining exposures it can actually be useful to avoid subject movement. Fast-moving clouds, for example, can change position substantially between exposures when bracketing manually, and this slight misalignment can cause headaches when trying to combine these images later with HDR software. But with auto-bracketing you can take five images in less than a second, minimizing the movement between frames. Just make sure that at least one image has highlight detail and one has shadow detail.

1
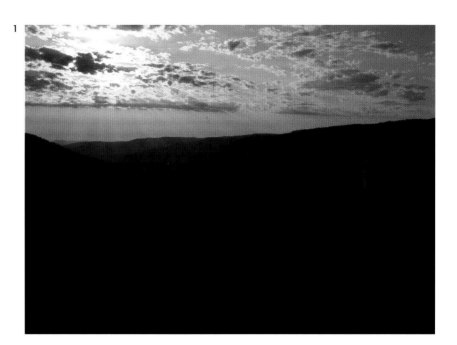

2
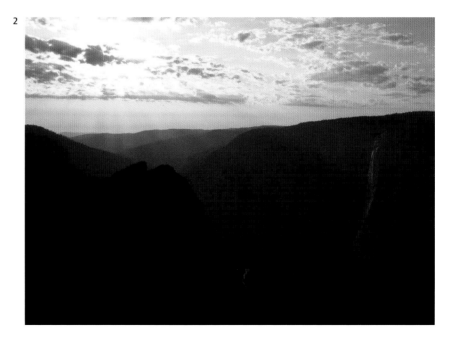

3

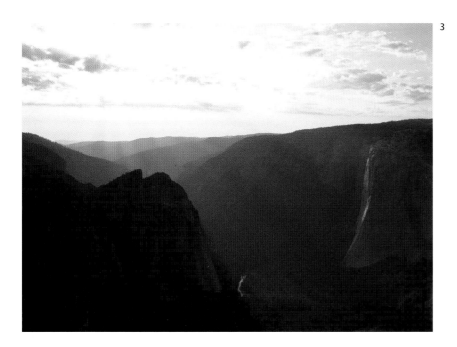

4

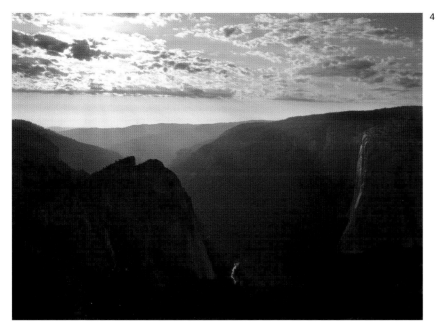

Photoshop Blend

The three original files (1-3) from this very high-contrast scene were manually combined in Photoshop using layer masks (see page 142). Each exposure was one stop apart. I allowed the bright clouds near the sun to become washed out—the brightest spots are probably Zone 10 in the final image (4)—to retain a sense of brilliance. Overexposed highlights usually look unnatural, but there are exceptions: the sun itself, reflections of the sun in water or glass, and bright clouds next to the sun.

1

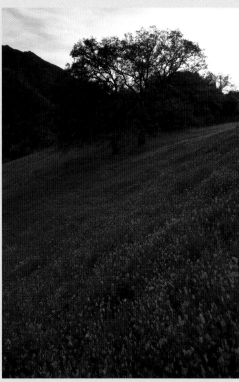

2

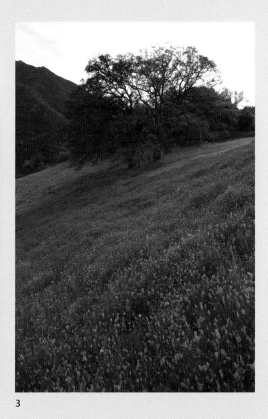

3

Photomatix Exposure Blend

I would never consider photographing this scene with color film—either the sky would be washed out, or the flowers would become dark and muddy. Here, with a digital camera locked firmly on a tripod, I made four exposures (1-4), each one stop apart, making sure the darkest image had detail in the bright clouds, and the lightest had good color in the foreground. Then I combined the four frames (5) using the Exposure Blending mode in Photomatix HDR software (see page 138).

In the darkest original (1), the brightest clouds are at Zone 7, and the flowers are six or seven stops lower—about Zone 0 or Zone 1. Some objects, like the tree trunks, are even darker. In the final image (5) the tree trunks were brought up to Zones 2 and 3 and the flowers to about Zone 4½, while the sky remained Zone 7. This extreme tonal compression is actually beyond the capabilities of the traditional Zone System. Aside from the fact that this image is in color, the highly reduced development needed

to retain detail in both the clouds and the foreground here would have flattened the local contrast, and the flowers would have looked dull look and unnatural. Here, the tonal compression is only taking place in the top third of the image. The bottom two-thirds of the final image is made entirely from the lightest original exposure, and I actually increased the contrast in this area when adding the finishing touches to this photograph.

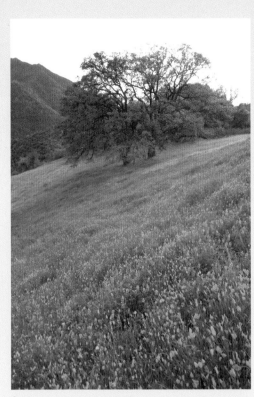

4

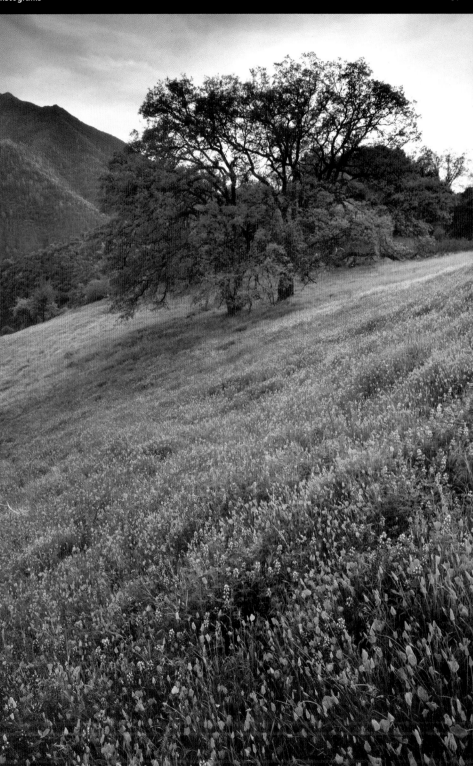

5

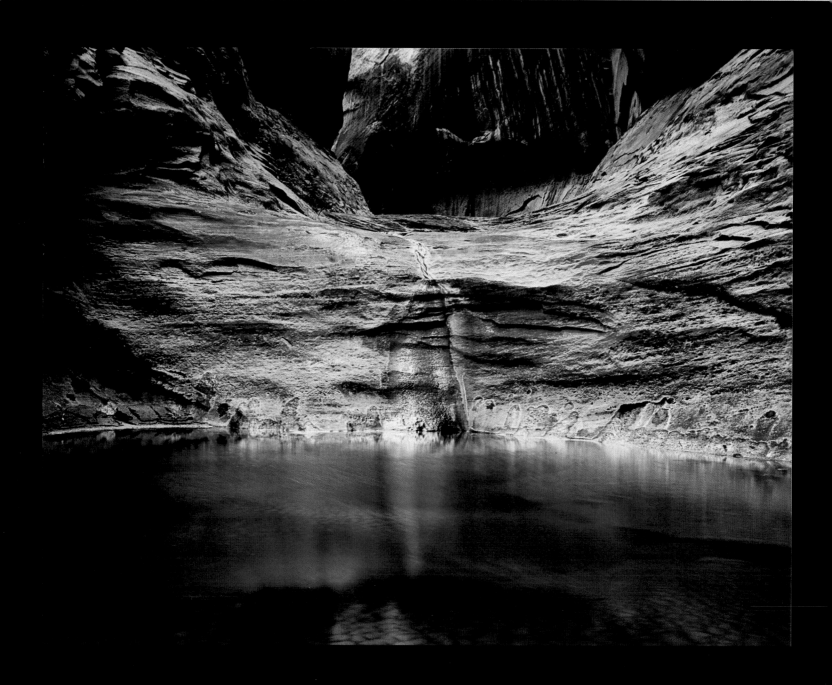

**Pool in Mystery Canyon,
Lake Powell, Utah,
by Eliot Porter**

Eliot Porter taught generations of color photographers how to see the landscape. He took the principal limitation of his transparency film, its high contrast, and turned it into an advantage by focusing on intimate scenes and emphasizing subtle colors and patterns.

Porter was one of the first people to consciously use photography to promote conservation. This image, *Pool in Mystery Canyon*, was originally published by the Sierra Club in *The Canyon No One Knew*, about Glen Canyon, in 1963. Construction of the dam that would fill the canyon began in 1956, and finished in 1966. The poignancy of this book, coupling Porter's beautiful images with the knowledge that all the scenes he depicted would soon be drowned by the rising waters of Lake Powell, helped spur the conservation movement into more vigorous action to prevent such tragedies in the future. In all, Porter published five books with the Sierra Club and helped put conservation into the mainstream of political conversation.

"The essential quality of a photograph is the emotional impact that it carries."
—Eliot Porter, 1987

Technique, while important, is only a first step. Mastering exposure and depth of field will help convey your idea, but you have to have an idea to convey in the first place. As Ansel Adams said, "There's nothing worse than a sharp image of a fuzzy concept."

Light

Edward Weston said, "The most important element with which the photographer must deal is light. Camera, lens, film, developer, and printing paper have but one purpose: to capture and present light. Yet for all its place of importance in the photographic scheme, light is too often unknown, unstudied, and abused by photographers today."

It may seem obvious that landscape photography requires an appreciation of light, yet how many of us have really studied it? Weston once advised a friend to "go out with his camera and study light at first hand: To see what it does to familiar and unfamiliar objects— a tree, a face, a cloud, or a cloudless sky. To look at the same scene at every hour of the day—not glance—but look with understanding, until he learned to see objects in terms of their light quality." His son Brett put it more succinctly: "If you've no sense of light, you may as well forget about it."

Composition

For many photographers, no aspect of photography is more difficult than composition. Perhaps for that reason, people have tried to create rules for composing photographs. But the landscape masters of the past were unanimous in their disdain for such formulas. "To consult the rules of composition before making a picture is a little like consulting the law of gravitation before going for a walk," said Weston.

While rules (maybe guidelines would be a better word) can be helpful in some situations, the world is too complex for any rule to apply in all situations, but there is one principal that always applies: simplicity. The best compositions contain only the essentials of the scene or subject, and nothing extra. Or, to quote Weston again, "To compose a subject well means no more than to see and present it in the strongest manner possible."

Good compositions almost always have something else in common: a strong, abstract design. Too often photographers become trapped into thinking in terms of subjects rather than designs. When photographing a tree, for example, many photographers approach the scene with a pre-formed mental image of what a tree is supposed to look like, instead of seeing the unique qualities of the particular tree they're photographing. As Ansel Adams said, "The photographer should not allow himself to be trapped by something that excites him only as subject; if he does not see the image decisively in his mind's eye, the result is likely to be disappointing."

Mood

Ultimately, the best photographs are not just interesting, or even beautiful—they capture a mood or feeling. They evoke a reaction in the viewer. Adams felt that the photographer had to respond to a subject before the viewer could: "I have made thousands of photographs of the natural scene, but only those visualizations that were most intensely felt at the moment of exposure have survived the inevitable winnowing of time."

Adams' unique ability to capture the grandeur and mood of the American landscape cemented his place in photographic history, and in the hearts of millions of viewers. His best images convey the monumental quality of mountains or deserts, but also capture the feeling of a particular moment when the light, clouds, and weather were just so.

To infuse your own photographs with mood, you must pay as much attention to light and weather as Adams did, and use every possible visual tool—line, shape, pattern, tone, color, movement, exposure, and depth of field—to emphasize the feeling you're trying to convey.

This image of the Three Brothers from Yosemite uses light, weather, contrast, tone, color, and repeating triangular shapes to convey a feeling of serene grandeur.

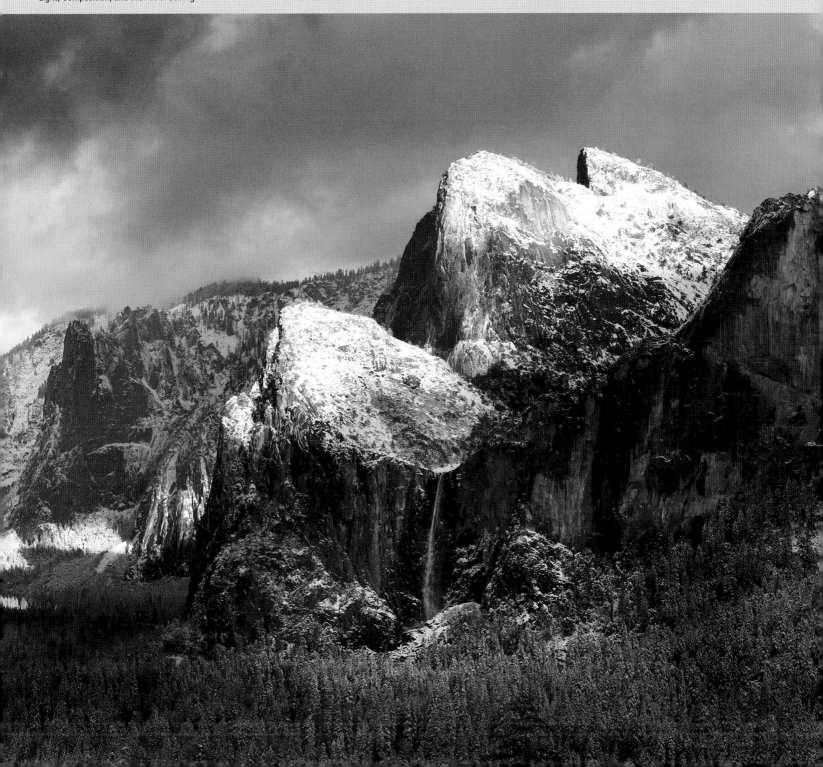

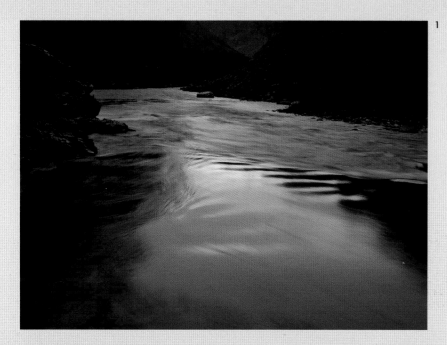

Light

*"It cannot be too strongly emphasized that reflected
light is the photographer's subject matter. Whether you
photograph shoes, ships, or sealing wax, it is the light
reflected from your subject that forms your image."*
—Edward Weston

We don't photograph objects. We photograph the
light reflected from objects. A great subject with poor
light makes a poor photograph. An ordinary subject—
one that most people wouldn't notice—can make a
great photograph with the right light. Landscape
photographers must become fluent in the language
of light.

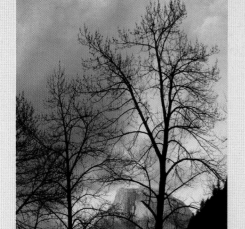

Directing the Eye

1 Bright Spots

Look at this photograph from the
Grand Canyon. What draws your eye?
If you said the center of the image,
you're not alone. Bright spots attract
attention, while our eyes—and
brains—tend to ignore dark areas.

2 Warm Colors

Warm colors like red, orange, yellow,
and magenta also grab attention.
In this image, although Half Dome is
no brighter than the blue sky, it draws
the eye because of its warm color.

3 Visual Conflict

When the brightest spot in the photo
is not the main subject—not what you
want people to look at—you have a
problem. The sunlit area in the
upper-left portion of this image (3A)
draws attention away from the main
subject, the waterfall. The result is a
visual conflict between the waterfall
and the sunlit cliff.

Faced with such a conflict, you
come back when the light is better,
or try a different composition. In this
case (3B) I used a longer lens and
juxtaposed the bottom of the
waterfall with the sunlit tree. Now
the two main subjects stand out
clearly against darker surroundings
and don't compete with other
bright spots.

4 Dark Spots

The exception to this rule—that bright
spots attract attention—is when most
of a photograph is light. Then any
contrasting dark area attracts the eye.
These tufa towers at Mono Lake stand
out against brighter surroundings.

2

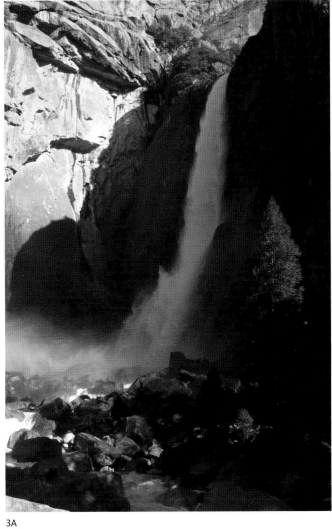

3A

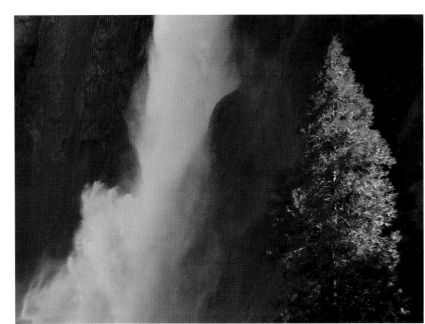

3B

4

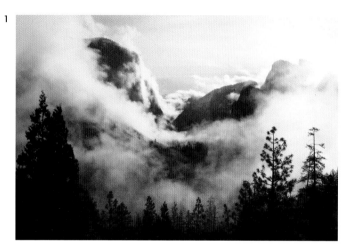

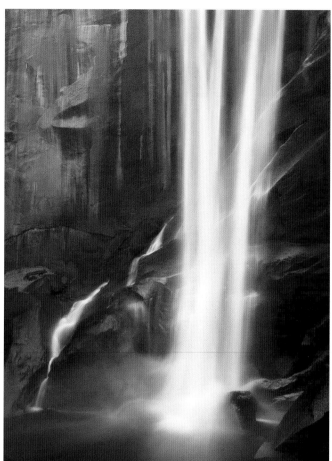

1 & 2. **Contrast**

A photograph can have light-and-dark contrast, color contrast, or both, but with little contrast it will look flat and uninteresting. This image from Tunnel View in Yosemite (1) has strong light-and-dark contrast, but little color, while the wildflowers (2) have vivid color contrasts, but no bright highlights or dark shadows.

3. **Seeing in Black and White**

Some photographers see the world in black and white, while others are drawn to color. Few do both well. Eliot Porter understood this: "When Ansel Adams photographs something, he sees it as a black-and-white image right away, and so he photographs it that way. I see it as a color image right away."

Adams is known for creating prints with a rich, full range of tones, from deep black to brilliant white. This contrast helps convey the drama that his images are famous for. But his images aren't harsh. The areas of pure black or white are usually quite small, with a full spectrum of grays in between. As Adams said,

"Marvelous effects are possible within a close and subtle range of values."

Making good black-and-white photographs requires visualizing the relationships between lighter and darker tones. The most effective images often use a clear juxtaposition of light against dark or dark against

4

4. **Seeing in Color**

light, as in this image of Bridalveil Fall (3). But notice that there's little pure black or pure white in this photograph. Most of the tones range from dark to middle gray, with some light grays in the waterfall.

Photographers who "see" in color often find colorful subjects, then build compositions around them. They make color the subject of the photograph. Subtle colors often work as well as rich, saturated ones. This image of Calf Creek Falls in Utah lacks vivid reds or yellows, but its rich and varied palette adds contrast and texture, and the photograph would

clearly be less effective in black and white.

While compositions can be designed around color, a random arrangement of hues won't work—you have to find a way to create order. Here the parallel lines in the rock and waterfall help to organize the color palette into a coherent whole.

1

2

The Four Basic Types of Light

Soft Light

"I began to see the effect of available light on my subjects, either from a clear blue or from an overcast sky, and I began to recognize that direct sunlight was often a disadvantage, producing spotty and distracting patterns."
—Eliot Porter, 1987

Porter was one of the first people to recognize what many photographers have realized since: that soft light is often the best complement to colorful subjects. When there's no direct sunlight in the scene, the light is soft and diffused, striking the subject more or less evenly from all directions. Since the light itself won't provide contrast, the subject must have its own. This is great light for flowers, autumn leaves, or anything colorful.

Forests often present a chaotic array of trunks, branches, and leaves. Shade or overcast conditions can simplify these scenes, but only if bright patches of sky are kept out of the frame. As Ansel Adams pointed out, "One problem with forest scenes is that random blank areas of sky seen through the trees can confuse the spatial and tonal continuum of the composition. In reality such interruptions are logical and accepted, but in a photograph they can be extremely distracting. The sky is usually much brighter than foliage, and these bits of blue sky can be considerably overexposed and blankly white." Telephoto lenses can help to narrow the focus of the composition and crop out the sky.

Soft Light and Color

While sunlight can overwhelm color, soft light seems to make colors glow, as in this image of redbud and oak trees (top).

Subtle Color

Colors don't need to be intense to be effective. Soft light can bring out the subtle, nuanced colors in subjects like this snow-covered oak tree.

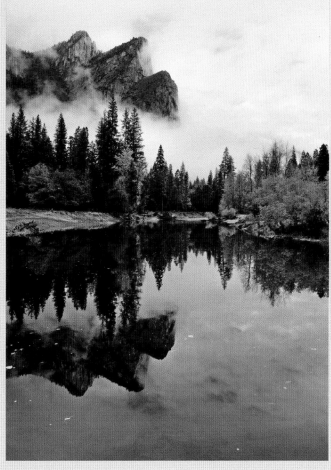

Simplification

Forest scenes are often chaotic, and splotchy sunlight filtering through the trees just adds to the confusion. Soft, late-day shade simplified this busy scene of a dogwood and giant sequoia.

Big Subjects

Soft light usually works best with medium or small subjects. It's difficult to photograph big, sweeping landscapes on an overcast day, because these scenes often need the punch provided by sun and shade, and bright, washed-out skies can be distracting. This photo of the Three Brothers is a rare exception. It works because there's contrast, including color contrast, and the sky is not completely blank.

Frontlight

Frontlit Color

Putting the sun at your back creates even lighting—much like soft light—as shadows fall behind objects. This uniform illumination can be too flat for many scenes, but it works well for colorful subjects, like these poppies and goldfields. The shadows here are small, and touches of black help set off the colors.

Quartering Light

Direct frontlight is often too flat, but putting the sun at a slight angle—over the shoulder instead of directly behind you—can introduce shadows and create contrast and texture, as in this scene of the Courthouse Towers in Arches National Park, Utah. Note the shadows raking diagonally across the foreground and outlining the left sides of the rock formations.

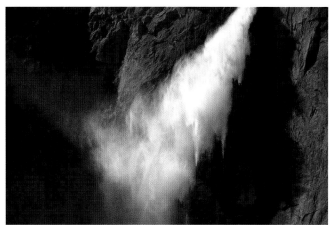

Frontlit Silhouette

We usually associate silhouettes with backlight, but one of my favorite types of light is the frontlit silhouette. This situation can occur anytime the sun is at your back but an object in the foreground is shaded. In this scene from Joshua Tree National Park, the morning sun was striking the clouds and rock formations, but hadn't yet reached the foreground Joshua tree.

Sidelight

Texture and Form

Sidelight, with the sun raking across the scene from the left or right, can be exquisite, especially when the sun is low in the sky. It can accentuate the texture, roundness, or three-dimensional form of an object. In the image of Yosemite Falls, sidelight brings out the texture of water and rock, while it highlights both the texture and form of the sand dunes in Death Valley.

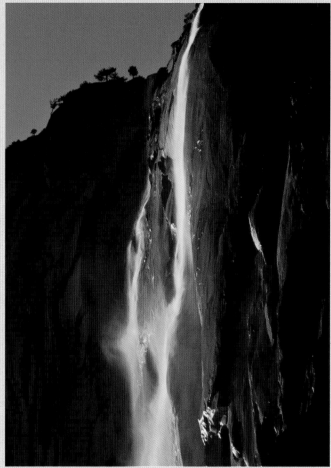

Backlight

Many people avoid backlight. Perhaps they once owned
an Instamatic camera and took to heart the words in
the little instruction pamphlet: "Always photograph
with the sun at your back."

Please ignore that advice and look into the sun.
Backlight is too interesting to avoid. Yes, exposures
can be difficult, and lens flare problematic, but when
it works it's beautiful.

Translucence

Translucent subjects seem to glow
when lit from behind, especially
when placed before a dark backdrop.
For these dogwood blossoms I found
some shaded trees to use as a
background, and used a 200 mm lens
to narrow the angle of view and avoid
including bright patches of sunlight.

This photograph of Horsetail Fall
in Yosemite (right) uses the same
principle—a translucent, backlit
subject against a dark background.
For only about one week every year
this fall is lit by the setting sun while
the cliff behind it is in the shade,
creating that perfect backdrop.

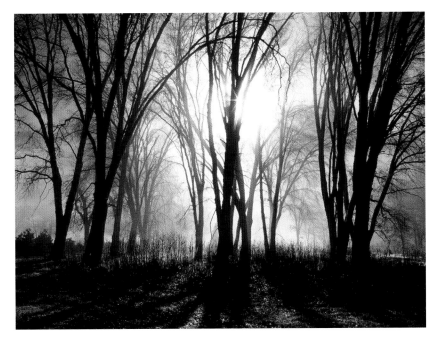

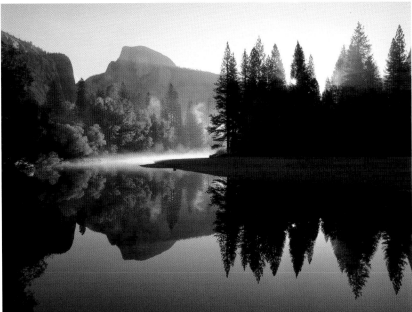

Silhouettes

Backlight can also create silhouettes. This is almost the opposite concept: instead of putting something translucent against a dark background, you set something opaque against a light background. Since the silhouetted subject is usually black, or at least dark, it must have interesting lines or shapes, like the spreading forms of these oak trees.

Lens Flare

Pointing the camera toward the sun can create lens flare—bright spots, streaks, hexagons, or an overall washed-out look. If the sun is outside the frame, just stick your hand out and shade the front of the lens to make these artifacts disappear. Of course, be sure to keep your hand out of the picture! It's difficult to hold the camera with one hand and shade the lens with the other, so use a tripod.

It's possible to keep the sun in the frame, but you have to hide it behind something, like a tree, rock, building, or mountain. Try to catch just the edge of the sun poking out from behind the object to add a bright focal point, but keep most of the sun hidden to avoid flare. A small aperture ($f/16$ or higher) can create rays around the sun.

In this image of Half Dome and the Merced River I positioned the sun behind a tree to avoid flare, and used a small aperture ($f/22$) to create the rays radiating out from the bright point of light. This photograph has both silhouettes (Half Dome and the trees) and translucence (the mist and yellow leaves).

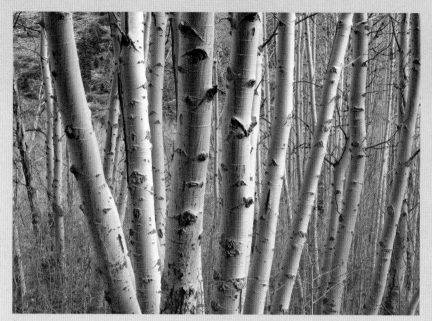

1

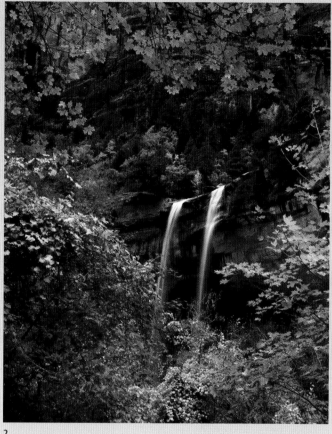

2

Beyond the Basics: Subtleties of Light

"The possibilities of natural light are so infinitely great they can never be exhausted. In a lifetime you could hardly exhaust all of the light-possibilities for a single subject, and the world is over-crowded with subject matter as yet untouched by the camera."
—Edward Weston

Soft Light with Direction

Soft light isn't uniform, or perfectly even—it's always stronger from one side. I photographed these aspen trunks (1) after the sun had passed below a ridge to the west—to the right as you look at this image. Full sunlight would have been too harsh for this scene, but soft sidelight kept the contrast low while still emphasizing the roundness and smooth texture of the trunks.

Under an overcast sky, more light strikes the top of an object than the bottom. In this photograph from

Emerald Pools in Zion National Park (2), I pointed the camera up slightly so that the trees were softly backlit. The translucent leaves glow with the light coming mostly from behind, but the contrast under overcast skies didn't overwhelm the scene.

Use directional soft light the same way you would use its harsher sunlit cousins: soft frontlight for color contrasts, soft sidelight to show texture and form, and soft backlight for translucent objects.

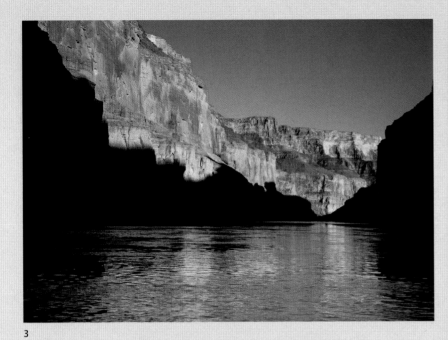

3

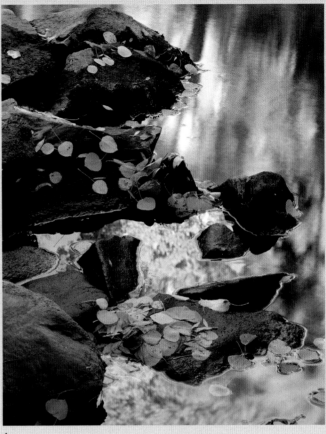

4

Reflections

"In rills and puddles, water also reflects the sky, giving some marvelous effects in surroundings of quite a different color."
—Eliot Porter

The best reflections show sunlit objects reflected in shaded water. Sunlight glaring on the water's surface kills reflections. Look for mountains, hills, or trees that catch late sunlight after the water below has slipped into shadow (or the opposite in the morning).

Smooth, mirror-like water is great, but not essential. Ripples, reflecting a kaleidoscope of hues, are often more interesting. A fast shutter speed freezes this wave pattern, while a long exposure can blur the water's surface into a beautiful sheen.

The first from the Grand Canyon (3) shows shaded water reflecting sunlight cliffs and sky. In this case the textured water is more effective than a smooth mirror. The second photograph, from the east side of the Sierra Nevada (4), depicts sunlit aspen trees reflected in a creek. Here a slow shutter speed smoothed the water's ripples.

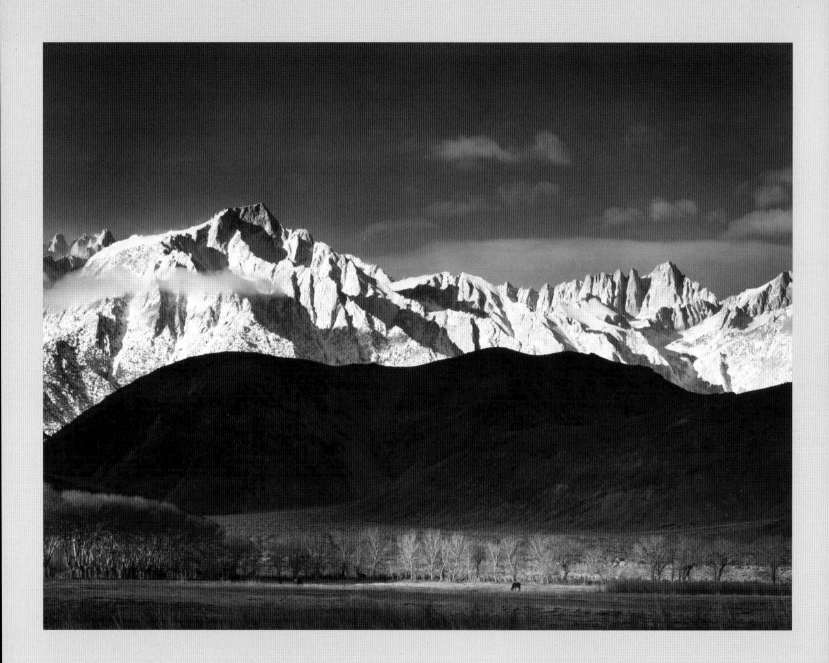

Chiaroscuro

Chiaroscuro is an art term used to describe dramatic contrasts between light and dark; Rembrandt was the most famous practitioner. In landscape photography, broken sun and clouds can create chiaroscuro.

Sunbeams highlight some landforms, while others are thrown into shadow, forming contrast even with the sun behind you. Of course you want the light to highlight the most interesting points. This takes timing, patience, and a little luck. "Waiting" and "photography" are synonyms in my dictionary.

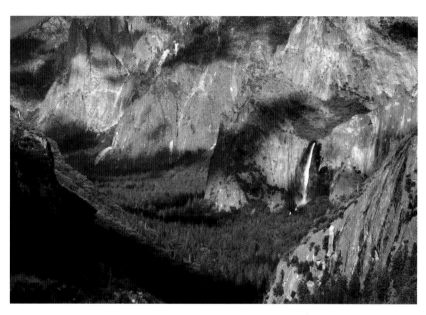

Winter Sunrise, Sierra Nevada, From Lone Pine, by Ansel Adams

Ansel Adams was intimately familiar with the most subtle aspects of natural light, and used this knowledge to give his photographs emotional impact. With his wife Virginia he set up his camera on a frigid morning near Lone Pine, on the eastern side of the Sierra Nevada, and waited for light, clouds, and a horse to cooperate. "A horse grazing in the frosty pasture stood facing away from me with exasperating, stolid persistence. I made several exposures of moments of light and shadow, but the horse was uncooperative, resembling a distant stump." Finally, as the last shaft of light approached, the horse turned to show its profile, and Adams made his exposure. "Within a minute the entire area was flooded with sunlight and the natural chiaroscuro was gone."

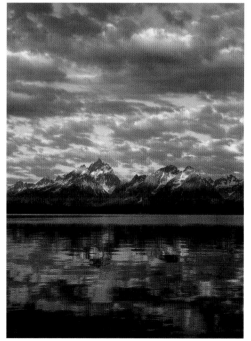

In this first image from Yosemite Valley I was lucky enough to find an almost perfectly balanced pattern of sun and shade, with light striking the focal point, Bridalveil Fall. The second photograph shows another fortuitous combination of weather and light, with the sun breaking upon the Grand Tetons underneath dappled clouds.

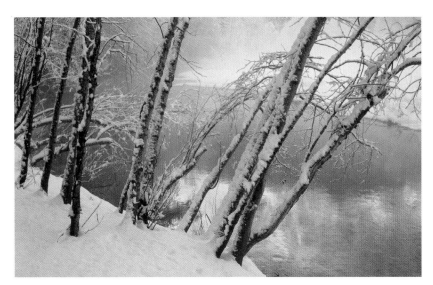

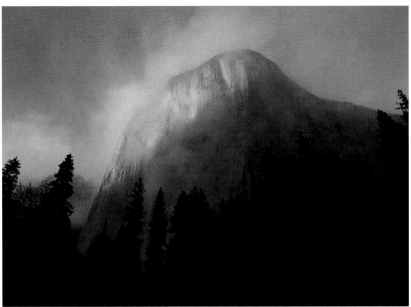

Color Temperature

The technical aspects of color temperature and white balance were covered on page 32. Some photographers become obsessed with capturing perfectly neutral white balance, but with any image the goal is not to meet some artificial standard—the goal is to create a good photograph. Color temperature can be a creative tool. An overall tint—like blue or magenta—can add to the mood, and differences in color temperature can be aesthetically pleasing—they create a warm-cool color contrast. I didn't correct for the blue tint of the snow covering these alder trees; I left the snow blue so that it would contrast with the warm, golden reflections in the river.

The most vivid contrasts in color temperature occur around sunrise or sunset. Sunlit objects become orange, red, or pink, while the sky and shaded areas remain blue, as you see in this El Capitan photograph. Frontlight, sidelight, and backlight are all more interesting early and late in the day; the low angle of the sun creates more dramatic shadows and contrasts, and the most drab subject can become colorful.

Bounce Light

While Yosemite photographers look for storms and interesting weather, their Utah cousins hope for clear skies. In the Southwestern United States, sunlight bounces off red canyon walls and casts a beautiful amber glow on objects in the shade. Deep in Buckskin Gulch, along the Arizona-Utah border, I found sunlight reflecting off rock and sand to illuminate this bend in the canyon.

Desert photographers don't have a monopoly on bounce light. In cities, light reflects off glass buildings, adding a surreal glow to the streets below. The sun can rebound off snow or sand to illuminate the underside of a tree. Early or late in the day, any valley or canyon can reflect sunlight off its walls into the shade below.

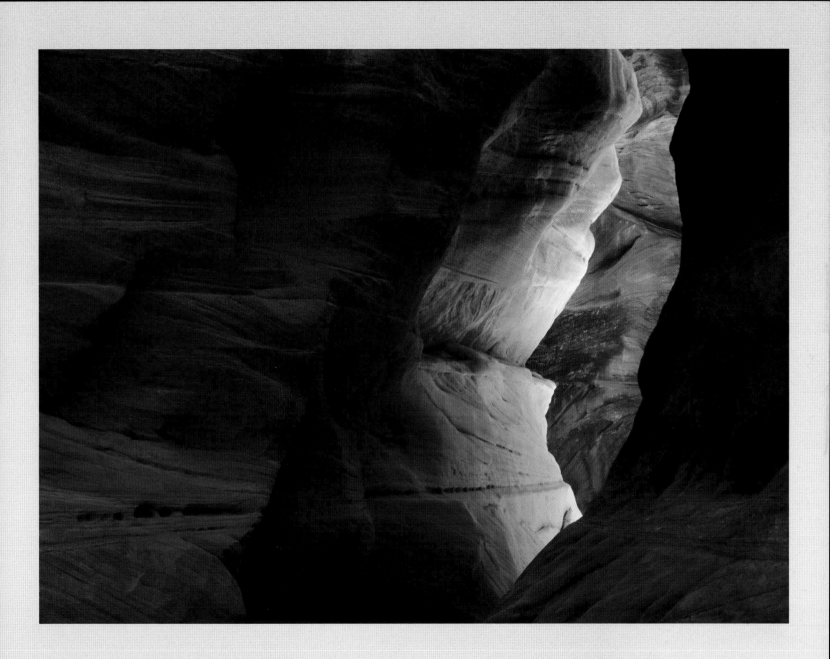

1

2

Composition

"The art of photography is knowing how much to exclude. You can't photograph the whole world."
—Eliot Porter

Painters start with a blank canvas and add their vision to it. Photographers start with the entire universe, pick one small piece of it, put a frame around it, and invite people to look at what they found. Photography is an act of reduction. The more you eliminate, the better the photograph will be. The fewer the elements, the stronger their impact. Less is more.

The Rule of Thirds and the Golden Mean

The rule of thirds says that if you divide a photograph into thirds, both vertically and horizontally, those lines, and the places where they intersect, are strong points to put your main subject or a point of interest.

This rule is actually a simplification of the golden mean, golden ratio, or golden rectangle—ancient aesthetic concepts that espouse the beauty of a ratio of approximately 1.62. In practice, this is closer to $2/5$ than $1/3$—that is, using the golden mean you would place important objects $2/5$ of the distance from the left, right, top, or bottom of the frame.

No rule can cover every situation. I break these rules more than I use them, but they can be useful when I'm not sure where to place something. They serve as a reminder to keep the main subject out of the center. It's usually more interesting, more dynamic, to put the focal point off-center.

Golden Mean 3

1 & 2. The lone pine tree adheres
to the golden mean—it's about $2/5$
of the way from the right edge of
the photo. Bridalveil Fall also fits
this rule, as it lies close to $2/5$ of the
distance from the left border. While
these images happen to fall close
to the "ideal" of the golden mean,
adhering exactly to any artificial
standard is less important than
finding the right balance and
proportions for each situation.

3. The rule of thirds and golden
mean can also be used for horizons;
it's often best to place them $1/3$
to $2/5$ of the way from either the
top or bottom of the photograph.
I placed this horizon from Tuolumne
Meadows, in the Yosemite high
country, closer to the top to
emphasize the reflection.

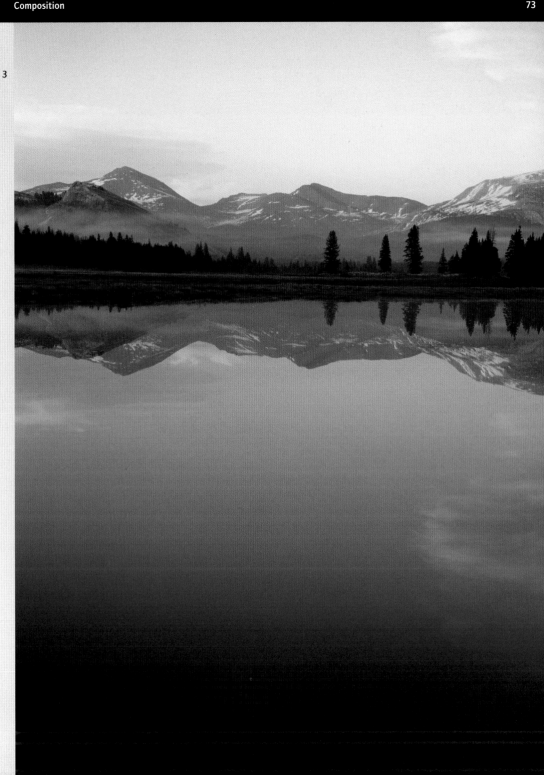

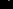

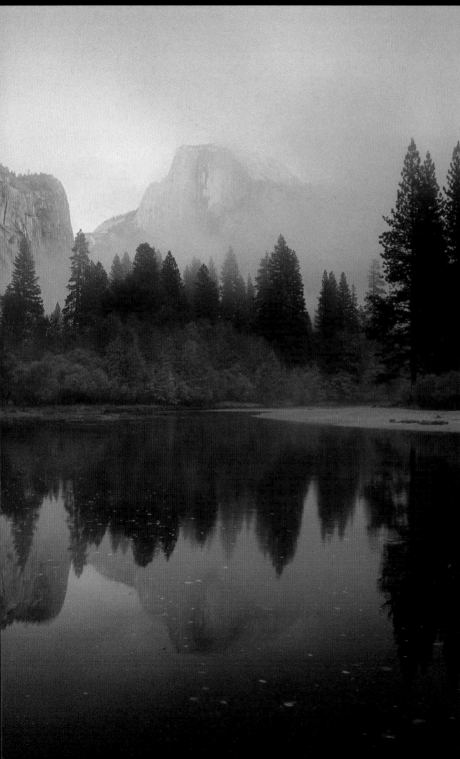

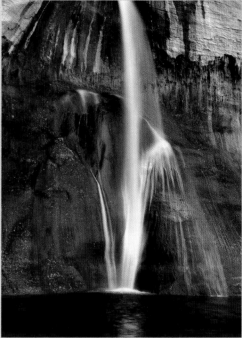

When to Break the Rules

Often! As Edward Weston said, *"Pictures came first. Rules followed. No one ever became an artist by learning rules or keeping them."*

4

5

1. Think of the rule of thirds and golden mean as a guidelines, reminders that a centered subject often looks static. But there are plenty of exceptions. With reflections, a centered horizon can be effective because it creates symmetry and emphasizes the feeling of calm, as in this image of Half Dome.

2 & 3. Sometimes the center is just the logical place to put something. This photograph of Utah's Calf Creek Falls would look off-balance if the waterfall wasn't centered, and the placement of the rose emphasizes it's symmetry.

4 & 5. Horizons can be placed near the bottom of the frame to emphasize the sky, as in this photograph from Gaylor Lakes, or near the top to emphasize the foreground, as with these wildflowers from Tuolumne Meadows.

6. Some photographs don't have a focal point—they're just patterns, like this field of lupine flowers, so the rule of thirds and golden mean don't apply.

6

The Only Real Rule: Simplify

*"For photographic composition I think in terms of
creating configurations out of chaos, rather than
following any conventional rules of composition."*
—Ansel Adams

The best compositions are simple. The photographer's
point stands out clearly without distractions or clutter.

The single most common photographic mistake is
including too much in the frame. Imagine someone
walking through Yosemite Valley who decides to
photograph Half Dome. Without thinking, he snaps
a picture. Later he notices that, in addition to Half
Dome, the photograph includes sky, trees, a meadow,
plus a large bus on the roadway, and Half Dome has
become lost in the chaos.

Don't be like him! Take a moment to think. What
caught your eye in the first place? Make the photograph
about that, and nothing else. If a composition isn't
working, move in closer or use a longer lens. Doing
either will automatically crop out unnecessary material
and simplify the design. If you're trying to combine
two elements, but they don't seem to mesh, then
concentrate on just one of them.

Less is More

The best compositions convey your
message clearly and directly. Nothing
competes with these tiger lilies—they
dominate the frame.

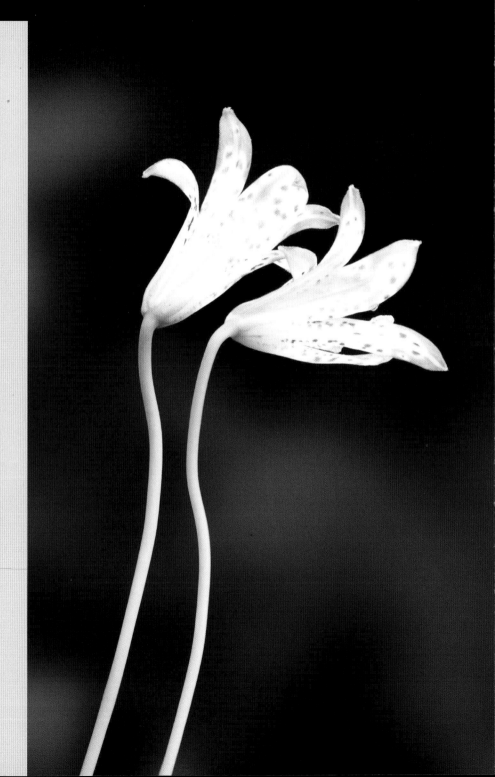

1

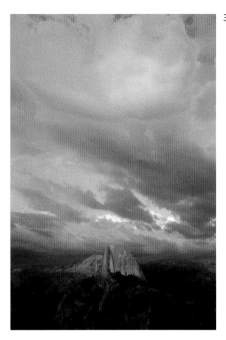

3

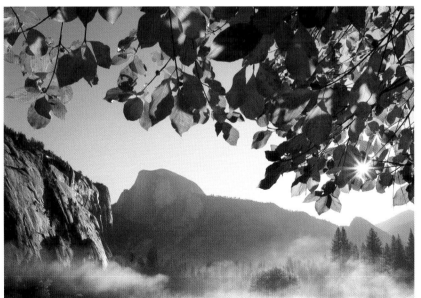

2

Finding the Essence

To find the essence of your subject, ask yourself what caught your eye in the first place. What compelled you to make the photograph?

These three photographs of Half Dome are all different, but each one includes only the essential elements. In the first image, the light and clouds around Half Dome were interesting enough by themselves—I didn't need anything else. So I used a telephoto lens to fill the frame with just the rock and clouds. In the second version

I wanted to juxtapose two objects, Half Dome and the backlit dogwood leaves. Here I used a wide-angle lens, which turned Half Dome into a small silhouette, but its distinctive shape is still recognizable, and the composition remains simple—most of the frame is filled with just the leaves and granite monument. In the third image I was attracted to the large, colorful cloud above Half Dome, so I put the rock at the bottom of the frame, pointed the camera up, and filled the image with only the two most important items.

1A

1B

1. Narrowing the Focus

In this first photo (1A) I was attracted to both El Capitan, and to the pattern of ice in the river. But it just didn't work. There were too many other things that I had to include, like the trees and snow on the opposite bank of the river, plus the horizontal lines in the bottom half of the frame didn't mesh with the vertical lines of El Capitan. So I decided to forget to just concentrate on the ice. This second version is much simpler and stronger (1B).

2. Eliminating Distractions

This first image of the small waterfall isn't bad (2A), but I felt that the dark rocks were distracting. I decided that what most caught my eye was the streaks of falling water and the golden reflection above, and used a longer lens and filled the frame with these most essential components (2B).

3. Adding Impact

This first photograph is a nice, straightforward rendition of Vernal Fall (3A). It shows what the waterfall looked like, but didn't capture the noise and power of the water. So I found a part of the fall that, to me, conveyed that feeling better (3B).

2B

2A

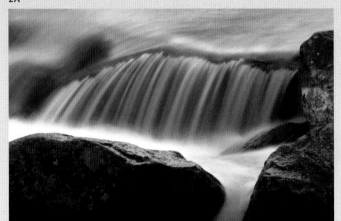

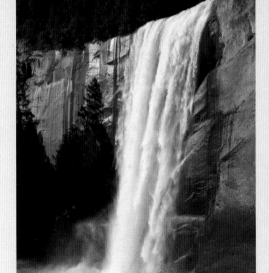

3A

3B

The Power of Lines

Lines

Do you even know what you're looking at here? Does it matter? The real subject of the photo is the abstract design—the descending series of squares. At its essence, every photograph consists of lines, shapes, tones, and colors on a flat surface. The more you look at your own photographs that way—as abstract designs—the better your images will be. Take it from Edward Weston: "How little subject matter counts in the ultimate reaction!"

Vertical Lines

Lines can convey feeling. A succession of vertical lines looks stately and monumental, like Greek columns—appropriate for the immense sequoia trees in this first photo. In the second image the vertical lines converge, helping convey a sense of height.

Horizontal lines

Horizontal lines convey tranquility and calm. The strong horizon line in this photo from the Yosemite high country adds to the peaceful mood.

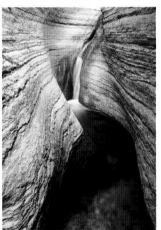

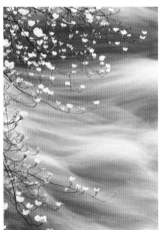

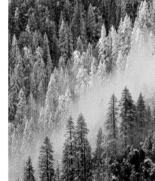

Curved Lines

S-curves, as shown in the first image from the Grand Canyon, can be a powerful way to lead the viewer's eye through a photograph. Curves can also create a sense of flowing movement, as in this second photograph of dogwood blossoms.

Diagonal lines

Diagonal lines create a feeling of movement and energy. These two photographs have very different subjects, but similar compositions, and both rely on strong diagonals.

Patterns and Repetition

Corn Lily Leaf Pattern

One leaf by itself is just a leaf.
Two similar leaves form a pattern.
Repetition creates rhythm, unity,
and strong compositions. If you find
a pattern, try to fill the frame with
it and make the viewer think the
pattern continues indefinitely.

Focal Point

It often helps to have a focal point;
a spot where the viewer's eye can rest
before roaming around the pattern,
like the yellow cottonwood leaf left
of center in this image.

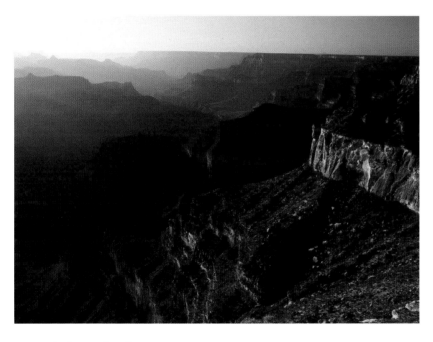

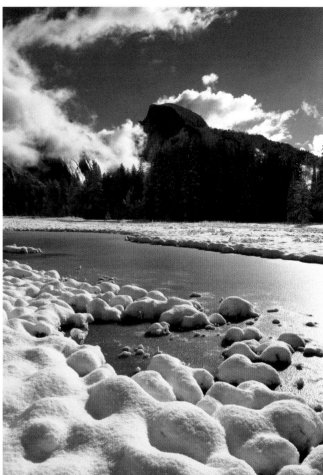

Patterns in the Grand Landscape

It's easier to see strong designs
in small subjects, but it's just as
important to find them in big,
sweeping landscapes. Notice the
diagonal lines and repetitive vertical
cliffs in this Grand Canyon image.

**Connecting the Foreground
and Background**

If the photograph has a foreground
and background, there must be lines,
shapes, or colors that tie the two
together; if not the photograph will
look disjointed. The mounds of snow
in this image echo the rounded shape
of distant Half Dome.

Changing Perspective

Too often photographers act as if their tripods had grown roots. They see a possible subject and stop in their tracks, never considering what might happen if they moved the camera to the left or right, up or down, forward or back. The first view of the subject is not necessarily the best one. Move around!

Ansel Adams said, "With practice, we can rapidly assess visual relationships and choose an appropriate camera position for any subject." The key word there is practice. Adams often turned this into a mental exercise while engaged in everyday activities. Simply sitting in a chair, holding a conversation, he might imagine taking a photograph of the person he was talking to, and how the visual relationships might change if he altered his point of view. It's a great exercise—try it sometime.

Camera Position

Consider how a change in camera position might have affected this image from White Sands, New Mexico. Lowering the camera would have merged the top of the spiky leaves with the dune's shadow. Stepping to the right would have merged the yucca's stalk with the curved ridge of the dune, while positioning the camera further left would have created too much separation between them. Moving closer with a wide-angle lens would have made the background dune smaller in relation to the foreground. Stepping back with a longer lens would have forced me to crop out some of the clouds. In short, there was only one appropriate position for the camera.

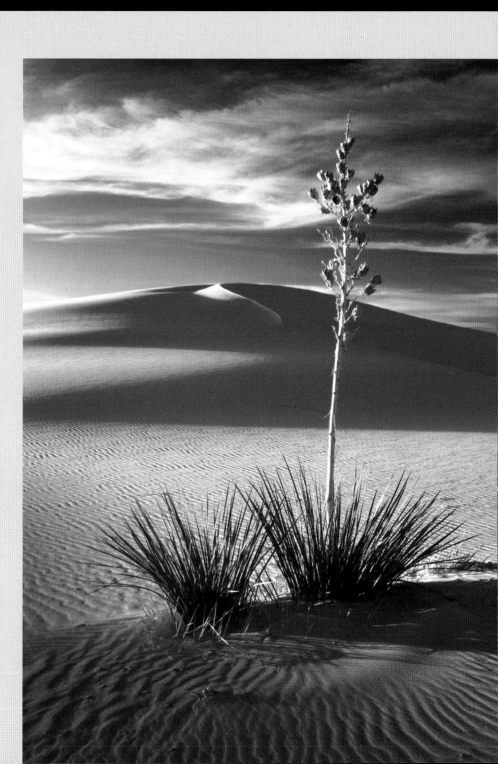

1

1. Viewpoint

Most photographs are made with the camera at eye level looking straight out toward the horizon. Breaking this habit can lead to more dynamic photographs. Adams built platforms on top of all his vehicles to give him a higher perspective. Try to look up or down and find higher or lower vantage points. Pointing the camera toward the sky created an unusual perspective on these aspen trees.

2. Telephoto Lenses

Telephoto lenses compress space—objects appear larger and closer together than they really are. You can use this to flatten images and create abstract patterns. Here the foreground ice was about 20 feet (6 m) closer to the camera than the background ice, but a 200 mm lens flattened the perspective into a surreal design.

3. Wide-Angle Lenses

Wide-angle lenses expand space. Objects look further apart and more distant than normal. You can take advantage of this by exaggerating the size difference between foreground and background to create an illusion of depth. Get close to something in the foreground, as I did with the rock strata in this photo from Zion, otherwise everything will look small and insignificant. It also helps to include converging lines, like those in the foreground rocks, to create a sense of perspective.

2

3

Capturing a Mood

The best images do more than show what something looked like—they capture a mood or feeling, and evoke a response from the viewer. Brett Weston said, *"Unless a landscape is invested with a sense of mystery, it is no better than a postcard."*

To convey mood, photographers must use all the tools discussed so far: exposure, depth of field, light, and composition. But there are a few more items that merit consideration, including tone, color, weather, and motion.

Tone

1. **Dark tones** suggest somber moods, as in this image of Bridalveil Fall.

2. **High contrast** helps convey drama in this image from Tunnel View in Yosemite.

3. **Light tones**, as in this photo of a misty ponderosa pine, create a mood that's, well... lighter—bright, even happy.

4. **Low contrast** creates a softer, more delicate feeling in another view of Bridalveil Fall.

1

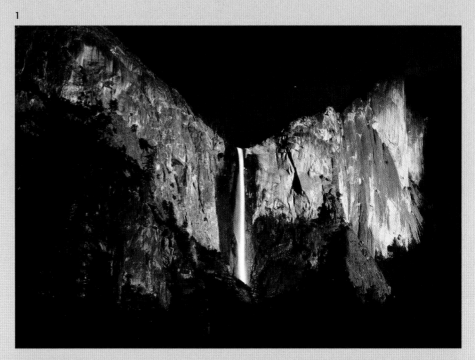

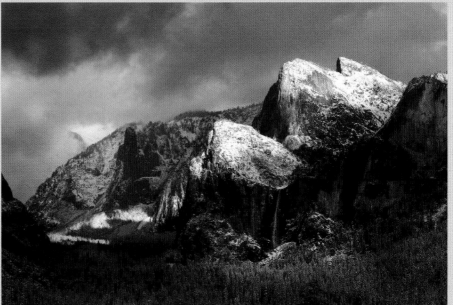

2

3

4

5

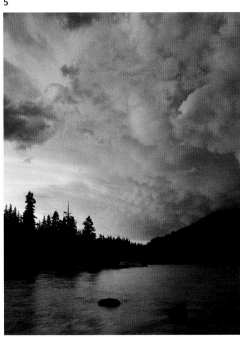

6

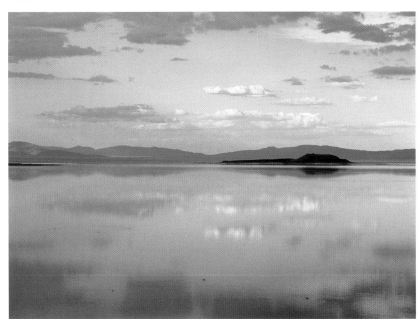

Color

Studies have shown that color can have a powerful effect on a person's mood. Interior designers create peaceful, serene rooms with blues and greens. Advertisers use red to grab your attention. Black can convey power, sexuality, elegance, or mystery.

Rain, Snow, Fog, and Wind

Any kind of weather can add interest to a photograph. Rain enriched the colors of leaves, bark, and moss in the image of oaks and granite. Snow provided the perfect complement to another oak tree in the second photograph. Fog added a magical quality to the third image, while wind created an unusual opportunity in the fourth photo: a flurry of falling leaves.

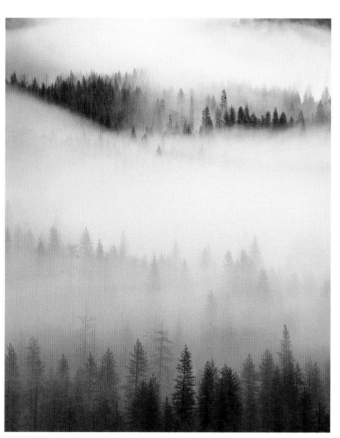

Clearing Storms

Many spectacular landscape photographs owe their drama to a clearing storm. A storm's aftermath can leave snow-covered trees, raindrops on flowers and leaves, fog, mist, and the sun breaking through clouds.

As the storm is breaking, try to determine where the sun is, and what it could illuminate if it does break through the clouds. Then you have a better chance of being in the right place at the right time.

I used my local knowledge to make this first photograph of Yosemite's El Capitan. In winter the sun strikes the west side of this rock at sunset, so I knew that if the sun peaked underneath the clouds there was a chance for dramatic light. The second image shows the eastern side of the same rock as the morning sun broke through remnants of a spring rainstorm.

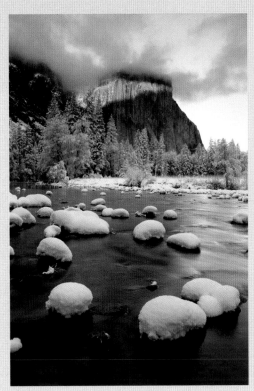
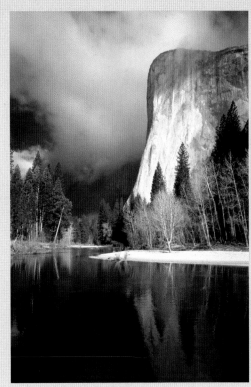

Weather and Atmosphere

We tend to think of landscapes as static, because the basic components, like rocks, trees, and bodies of water, change slowly. But the best landscape photographs often capture a particular instant, a unique, unrepeatable moment when the light, weather, and subject were just so.

This isn't just luck. Photographers can learn to anticipate such moments. They stalk their subjects, looking for those special combinations of light and weather. Many good images are made close to the photographer's home, or a place he or she visits frequently. Familiarity helps them find the best viewpoints, learn the patterns of weather and seasons, and anticipate when conditions will be right.

Ansel Adams made repeated visits to the Japanese internment camp at Manzanar during World War II. While there he scouted locations with photographic potential, and when conditions were right made some of his most famous images, including *Mount Williamson*, *Sierra Nevada*, and *Winter Sunrise from Lone Pine* (page 68).

Adams also lived in Yosemite Valley for ten years, and maintained a part-time residence there for the rest of his life. It's no coincidence that many of his best photographs were made there, like *Clearing Winter Storm* (page 102). There's a persistent myth that he camped at Tunnel View for days to make this image, but why would he camp when he lived only a few miles away? He did, however, return to this spot again and again when the weather looked promising.

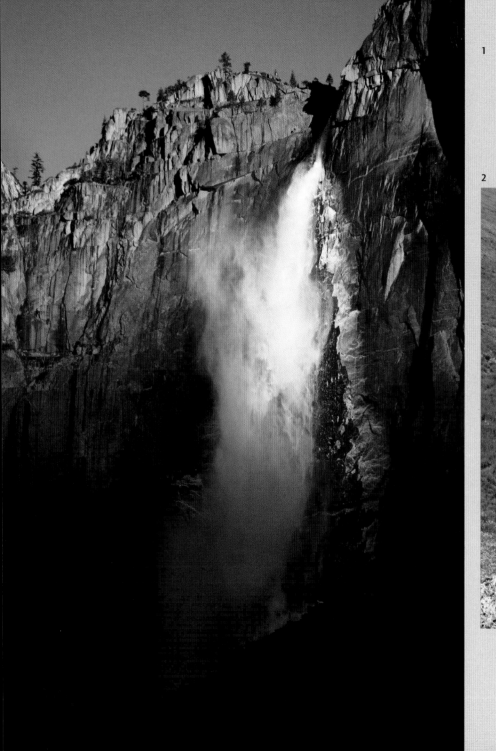

1

2

Seasons

Every place has seasons, even if they're not the traditional winter, spring, summer, and fall rotation. Each season—indeed, each week—offers unique possibilities. Not only that, but every year is different. Is it a wet spring or a dry one? Each can be equally beautiful. Is it a cold winter or a warm one? Both provide great opportunities for photographs.

1. Light changes from winter to summer. In winter, Upper Yosemite Fall receives beautiful early morning light, but in spring, when the fall is roaring, the sun doesn't reach it until 10 a.m. Therefore the best photos need a rare combination of winter light and unusually high water flow.

Unusual Opportunities

2 & 3. A wet winter led to an exceptional wildflower year in southern California, painting the hills with color. In the second image (3), an early snowstorm etched autumn aspens with snow.

3

Moon Cycles

Ansel Adams said he was "moonstruck," because of the inordinate number of moons in his photographs. Or maybe he just knew that the moon can add drama to any image.

Most people know the basic lunar cycle: 28 days from new moon to new moon. The ends of the cycle—new and full—are the most photogenic, as the moon hovers near the horizon at sunrise and sunset.

Moonstruck photographers should know that the moon rises (and sets) an average of 50 minutes later each day. So if it was in perfect position at sunset yesterday, it won't be today. The moon also rises and sets further to the north or south each day (except near the equator). This movement is too complex to describe in detail here, but remember that the full moon is always opposite the sun. You can find out local details using the internet. During summer in the northern hemisphere, the full moon rises from the east-southeast, takes a low path through the sky, and sets to the west-southwest—like the winter sun. In winter the full moon rises from the east-northeast, takes a high path through the sky, and sets to the west-northwest—like the summer sun.

1

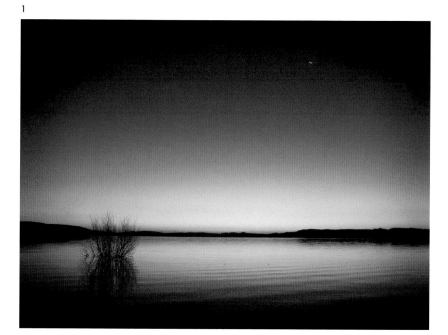

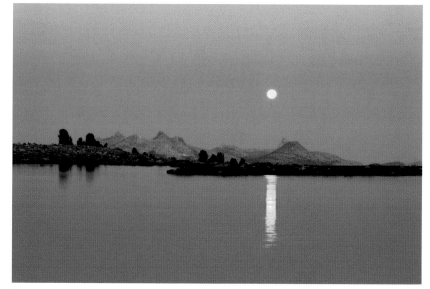

2

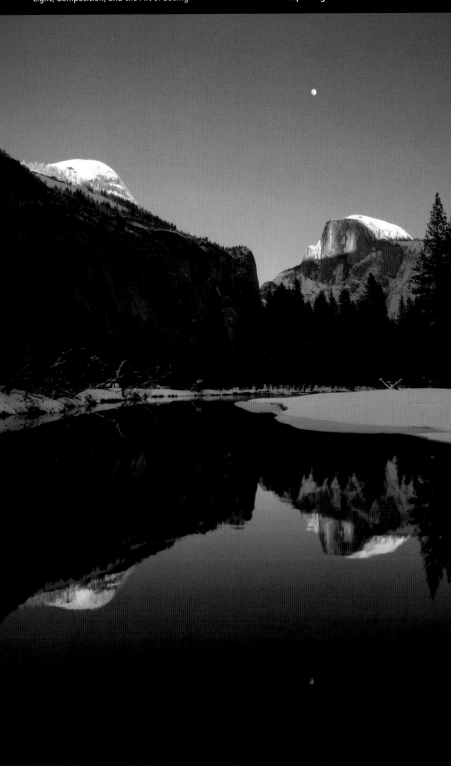

3

New Moon

1. The new moon is always close to the sun, so its crescent hovers near the horizon at sunrise or sunset. One or two days before the new moon that crescent will appear to the east around sunrise. A day or two after the new moon it can be seen to the west at sunset. This sunrise image of Mono Lake was made two days before the new moon.

2. The full moon can always be seen opposite the sun. It rises from the east at sunset and sets to the west at sunrise. The best images can usually be made before or after the actual full moon date. A day or two before the full moon, it rises to the east just before sunset, when there's still light on the landscape. One or two days after the full moon it hangs above the horizon to the west after sunrise. On the actual full moon date you may see the moon only when it's truly dark, making it difficult to capture detail in both the moon and landscape.

3. This image from Middle Gaylor Lake in Yosemite was made at dawn the day after the full moon. I saw the three-quarter moon rising above Half Dome at sunset three days before the full moon.

Conveying Motion

As the earth rotates, the sun, moon, and stars move through the sky. The wind blows, clouds grow, rain falls, water flows, animals run, birds fly, people walk, and cars drive. The world is in constant motion. Capturing that motion can add a powerful dimension to landscape photographs. But how do you convey movement in a still photograph? There are basically two ways: use a fast shutter speed to freeze motion, or a slow shutter speed to blur it.

1

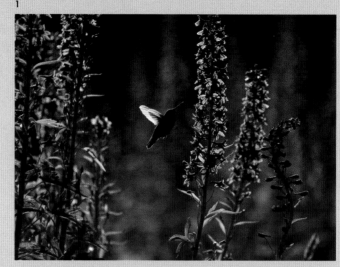

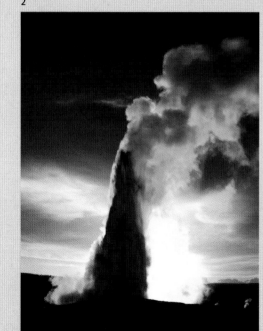

2

3

Freezing Motion

1. The Decisive Moment

Most photographs are static, so a fast shutter speed doesn't automatically convey movement. You must show something hanging in the air, or off balance. The viewer has to know that the subject couldn't stay suspended in that position.

Capturing such moments requires skill, timing, anticipation, and a little luck. You almost never catch the action the first time you see it, but if you're observant, you'll notice that events often repeat. I saw this hummingbird periodically visiting this group of flowers, so I sat and waited for it to return. It was shot at 1/3000 sec. Normally this wouldn't be quick enough to freeze its wings, but I happened to catch the wings at the top of their arc when they were relatively still.

2 & 3. Shutter Speeds

How fast should your shutter speed be to stop motion? It depends on how quickly the subject moves across the frame. A relatively slow shutter speed might freeze an object moving toward or away from the camera, but the same object moving across the frame would need a faster shutter speed.

To freeze motion you may need to set a lower f-stop (wider aperture) to get the necessary shutter speed. Of course this means less depth of field. If you can't afford to lose depth of field, or the light is too low to get the right shutter speed even at $f/4$ or $f/5.6$, try increasing the ISO setting.

This distant view of Old Faithful geyser (2) required only 1/125 sec to freeze its spray, but the tighter view of Yosemite's Silver Apron (3) required a shutter speed of 1/1000 sec.

4

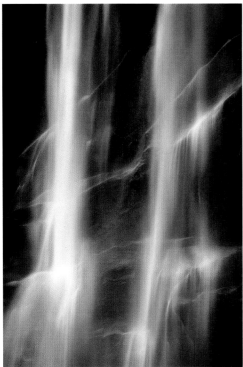

Blurring Motion

We're taught that photographs should be sharp. Terms like *blurry* and *out of focus* are not usually meant as compliments. Yet deliberate blurring can make powerful photographs. In real life we never see actual motion blurs; we view the world like it's a movie, a series of images in rapid sequence. So blurred motion creates an unusual look that can add a flowing, mystical, slightly surreal quality to a photograph. It also allows a period of time to be compressed and viewed all at once.

6

4 & 5. Still Camera, Moving Subject

This technique lends itself to many landscape subjects. It's now become standard to let flowing, cascading water blur. But this method can work with anything that moves—waves, stars, falling rain or snow, wind-blown flowers and branches, even moving cars.

The longer the shutter speed, the better these images usually look. Although there are no absolutes, in most cases you need a shutter speed of ½ sec or slower to give cascading water that silky, flowing look. You usually have to make these images in low light; even at your highest *f*-stop number (smallest aperture) and lowest ISO you can't shoot at ½ sec in midday sun without a neutral-density filter.

It usually helps to have something in the frame that's sharp to contrast with the moving, blurred subject. Of course that requires using a tripod, otherwise everything will be blurred from camera shake. In this close-up of Vernal Fall, a shutter speed of ½ sec allowed the water to blur, while a tripod ensured crisp detail in the rocks.

In the next photograph of reflections in the Merced River, everything is blurred. Yet it still works because the waves have their own structure, an organic pattern that holds the image together. The shutter speed was again ½ sec.

6. Panning

When panning, you're trying to capture a relatively sharp image of the subject while blurring the background. It's challenging: the subject must be moving in a steady and predictable way so that you can follow it smoothly with the camera. It helps if the background has some texture to create streaks behind the subject. Moderately slow shutter speeds like ⅛, 1/15, or 1/30 sec often work best. Slower speeds will give you a better blur, but it's hard to keep the subject sharp. This image of snow geese was made at 1/15 sec using a tripod with a panning head.

5

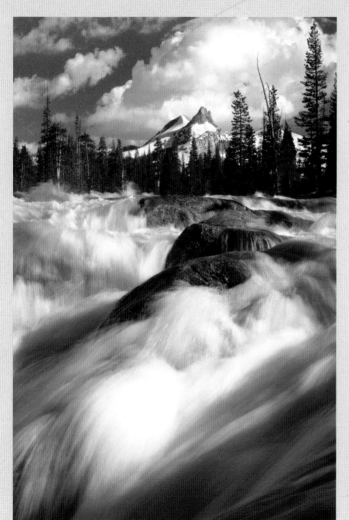

1

Retaining Texture

While very slow shutter speeds
(½ sec or slower) usually work
best for these images, sometimes
a moderately slow shutter speed
can retain more texture and detail.
Don't be afraid to experiment!
I used $1/8$ sec for this image of
Unicorn Peak and the Tuolumne
River in Yosemite, as this showed
more texture in the water while
still suggesting movement.

Wind

My initial idea was to let the water
blur while capturing a sharp image
of the redbud. Persistent winds made
this impossible, so I decided to let
the redbud blur also. I waited for
the biggest gusts and used a shutter
speed of 2 seconds to capture
maximum motion.

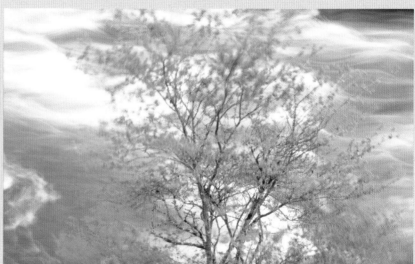

2

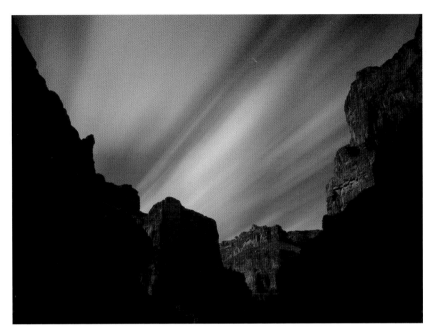

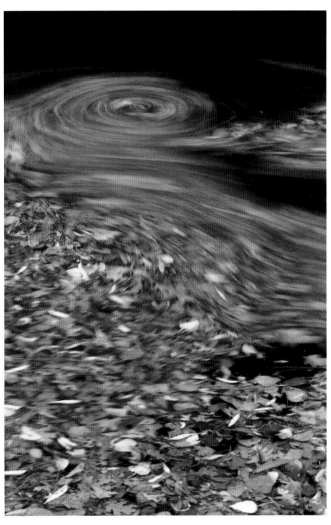

Nighttime Exposures

At night, light levels allow for very long exposures. The shutter was left open for eight minutes in this moonlit scene from the Grand Canyon, allowing the clouds to blur into streaks. The sky above Half Dome was exposed for 10 minutes, capturing parallel streaks of rotating stars and radiating lines of falling meteors from the Leonid meteor shower.

Visualization

It's often hard to imagine how blurred images will look, so digital cameras provide a huge advantage. Keep checking your LCD screen to see how the movement is rendered by the camera, and change your shutter speed or refine your composition if necessary. Although I could tell that these leaves were moving in a slow circle, I couldn't see the center of that circle with my naked eye. But as I photographed, that circular pattern appeared on my LCD screen, and I kept refining my composition until I got this image.

Expressive Images

Ideally, every single element in the photograph—
the subject, light, color, composition, weather, motion,
exposure, and depth of field—should contribute to
the photograph's message and mood.

Redwoods in Fog

Repeating vertical lines add a stately, monumental quality to these trees. The fog lends a touch of mystery. The tones are a mixture of light and dark; you can easily imagine how a darker or lighter exposure could alter the feeling. The colors are muted, which is appropriate for this subject—bright colors would destroy the mood. Everything is in focus; the trees need to be sharp to give them weight.

Oaks and Mist

Light and weather add an optimistic mood to this photograph. The contrast is high, but most of the tones are light. Sunbeams, mist, and a splash of yellow color all contribute to the bright, hopeful feeling.

The leaning shapes of the oak trees echo each other and give the photograph structure and repetition. Radiating and diagonal lines give this image energy.

Thunderstorm Over Mono Lake

Theatrical light and clouds add a dramatic mood in this photo. The long horizontal line of the horizon would ordinarily add a calm feeling to the image, but the turbulent shapes of the clouds create tension. Contrast is high, adding to the drama. The rainbow provides a clear focal point, but the rest of the image is essentially black and white. I used a 200 mm lens to zoom in on the most interesting and expressive part of this scene.

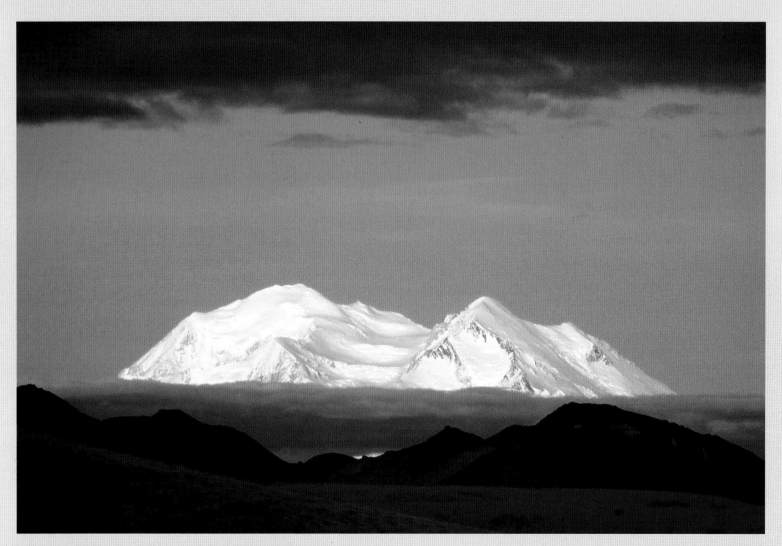

Mount McKinley

Dark tones at the top and bottom
of this image create a frame, as
if you were looking through
a window toward the mountain.
The juxtaposition of tones and lines—
the bright triangles of the mountain
thrusting up through the dark
horizontal lines of the clouds—
creates a feeling of grandeur.

A 300 mm lens filled the frame with
the most essential elements, and
added an unusual and somewhat
disorienting perspective by bringing
the foreground hills into visual
proximity with the snowy peak.

White Dome Geyser

A two-minute exposure by moonlight softened the water and added an ethereal, mystical quality to this photograph. The color palette—white, light blue, deep blue, black, and a touch of brown—also contributes to the peaceful yet mysterious mood. I pointed the camera up and used a wide-angle lens to include more stars and add to the expansive feeling. The overall composition couldn't be simpler.

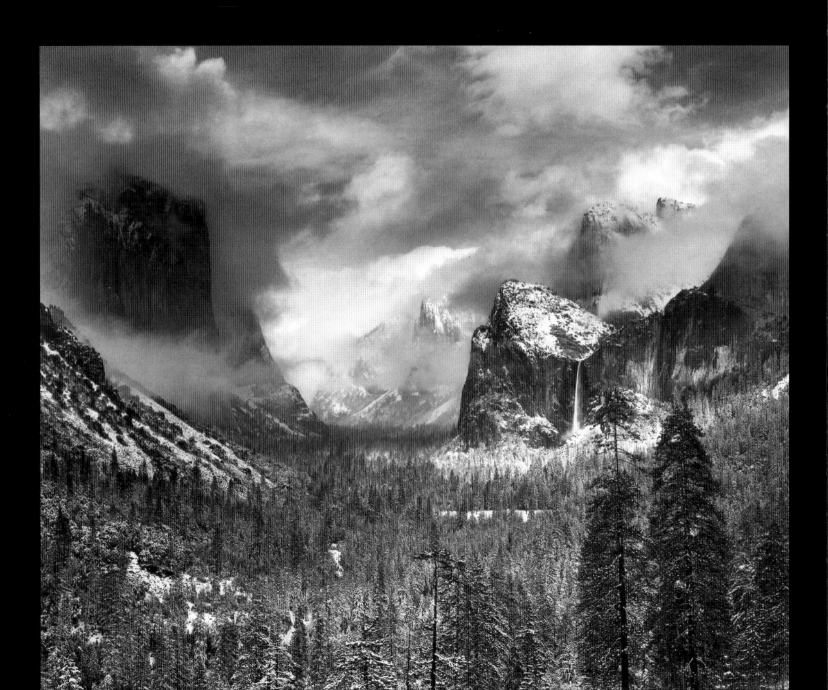

**Clearing Winter Storm,
Yosemite National Park, 1940,
by Ansel Adams**

This photograph reveals Ansel Adams'
darkroom mastery. A straight version,
with no dodging and burning, is
lifeless by comparison. But Adams
saw hidden possibilities: "Although
the scene was of low general contrast,
my visualization of the final print was
quite vigorous. The subject had a very
dramatic potential."

The process of realizing that potential
began by increasing the contrast
of the negative with a longer
development time (normal-plus-one).
Precise dodging and burning did
the rest. Adams used a metronome
to time his movements, dodging
(lightening) the two foreground
trees for two seconds, and burning
(darkening) the edges, top, sky, and
center for times ranging from one
to ten seconds. Adams' darkroom
skill created a masterpiece of light
and mood out of this seemingly
ordinary negative.

*"I think of the negative as the 'score,' and the print
as a 'performance' of that score, which conveys the
emotional and aesthetic ideas of the photographer
at the time of making the exposure."*
— Ansel Adams, 1983

To convey his "emotional and aesthetic ideas," Adams
became a master of black-and-white darkroom printing.
The kind of control he learned through painstaking
trial and error, using elaborate darkroom equipment,
is now available to anyone with a computer and the
appropriate software. In fact Adams might envy the
power that black-and-white photographers have today
to convert colors to shades of gray or precisely dodge
and burn their images.

But while black-and-white photographers have reason
to celebrate new digital tools, color photographers
might be excused for setting off fireworks. Black-
and-white darkroom printing had matured into a
sophisticated, beautiful process long before Photoshop
was invented, but analog color printing remained
complex and difficult. Perhaps the most beautiful
darkroom color printing process is dye transfer. It
involves making three matrices, one for each color
dye (the inks printed onto the page, cyan, magenta,
and yellow), then transferring each dye to the final
print. Each layer must be kept in perfect registration,
so the process takes years to master.

In 1940, Eliot Porter struggled to learn a precursor
to dye transfer called the washoff-relief process.
"The properties of the materials used," he said, "did
not always seem to conform to expected standards,
and thus it required a great deal of experimentation
to obtain even moderately acceptable results." The
complicated masking technique forced a tradeoff
between subdued colors or posterization. Eventually,
Porter became one of the great practitioners of the
"easier" dye transfer process.

It's telling that one of the modern masters of dye
transfer printing, landscape photographer Charles
Cramer, virtually abandoned this process at the
dawn of the digital age. In the late 1990s Cramer
experimented with digital printing from his

drum-scanned 4x5 transparencies. Several years later
he described his darkroom: "Everything was just as
I left it, covered with a layer of dust. It was like one
of those Anasazi ruins, with corn cobs lying around as
if the occupants had just fled." Cramer found that he
could make better color prints with the new digital
tools than with the painstaking dye-transfer process.

Modern digital printers, coupled with the sophisticated
controls offered by Photoshop and other applications,
can make prints as beautiful as any from the wet
darkroom. Learning to use these tools is one thing.
Learning the taste and judgment to make good prints
is another. While the methods have changed, the
aesthetics of a printing haven't. Here the landscape
masters of the past—particularly Ansel Adams, the
great darkroom technician—have much to teach us.

Adams said, "Print quality... is basically a matter of
sensitivity to values." This means finding the right
amount of contrast—enough to give the image life,
but not so much that it becomes harsh. It also means
knowing when a photograph needs a touch of pure
black for drama, or when subtler tones would convey
the right mood.

For color prints, the amount of saturation is also
key. Not enough and the photograph will look flat.
Too much and it becomes garish. The right color
balance is also vital. This doesn't mean locating
some theoretically neutral point, but rather
finding harmony between warm and cool hues.

Adams said, "The difference between a very good
print and a fine print is quite subtle and difficult,
if not impossible, to describe in words. There is
a feeling of satisfaction in the presence of a fine
print—and uneasiness with a print that falls short
of optimum quality."

Editing

Unrestrained by film and processing budgets, digital photographers can produce hundreds or even thousands of images in a day. How do you pick the best ones?

Start with an initial, quick look. First impressions are valuable. If an image strikes you right away as good, it probably is.

But while first impressions can be helpful, the key to good editing is objectivity, and objectivity increases with time and distance. I find it difficult to edit my work the evening after a shoot, but three days later it's easy. I've lost some attachment to my photographic offspring, and can look at them more objectively. So in the initial edit I only throw out the obvious dogs—images that are clearly overexposed, out of focus, or otherwise unusable. After a few days it's easier to pick the real winners.

Don't confuse effort with quality. Just because you spent months waiting for the perfect light doesn't mean the photograph is good. Try to look at the result, not the process.

It's common to collect sequences of similar images. There might be slight differences in composition, exposure, or focus. Perhaps they're all identical except that the subject was moving—you were trying to capture a waterfall when the spray was just so, or when the wind calmed and a field of flowers stood still. For checking sharpness it's invaluable to have software that allows you to zoom in and compare images side-by-side. A series of slightly different compositions is more difficult to edit. Again, first impressions help. Which photograph jumps out at you?

While time may allow more detachment from your photographs, another person is always more objective. But it has to be the right person. It's nice to have people in your life who love everything you do, but such people are worthless as editors. The ideal candidate has sophisticated visual taste (is not easily impressed by pretty sunset pictures), is completely honest, and can articulate what he or she likes or doesn't like about a photograph.

But don't hand over complete control to someone else. If, after living with an image for a while, you still like it—even if no one else seems to—stick with it.

1

3

2

4

Variations in Composition

Here are four similar photographs I made of pink and white redbud outside Yosemite National Park. Which one jumps out at you? Here it's best not to over-analyze—just go with your first impression.

I chose 3; it just seemed like the most satisfying composition. I like the spaciousness of 1, but the branch in the upper-left corner is distracting. 2 has too much space at the bottom, and no logical place to crop it. 3 and 4 are similar, but to my eye 3 has better rhythm and balance.

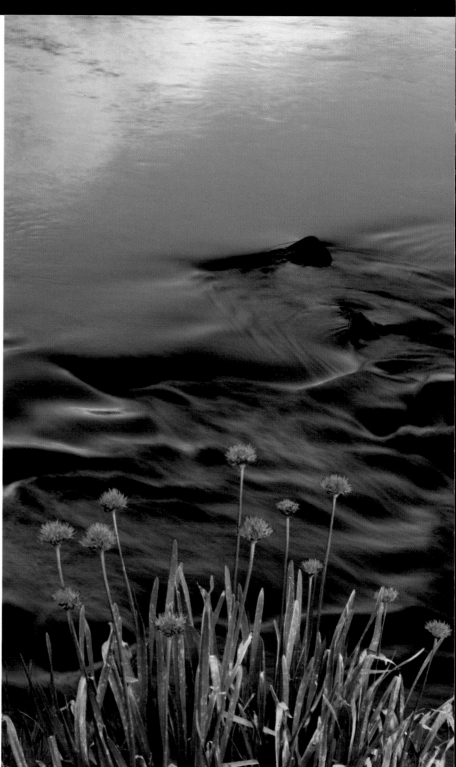

Raw Workflow

The straightforward processing required for this image—cropping, removing dust spots, adjusting contrast, and some minor burning—didn't require Photoshop, so I was able to do everything in Lightroom.

Photoshop Workflow

This photograph required Photoshop's sophisticated selection tools to lighten the foreground flowers without affecting the background water. I made only minimal adjustments in Lightroom before bringing the image into Photoshop.

Workflow

Ansel Adams, Eliot Porter, and Edward Weston each had their own post-processing workflow—a sequence of steps for developing, editing, and filing negatives, then more complex procedures for printing the best ones.

The tools may have changed, but a good, consistent workflow is still vital—perhaps even more so with the thousands of images that digital photographers often generate. A good workflow should be streamlined but powerful. You want to wring out maximum beauty with minimal effort. It also needs to be flexible so you can make changes later without having to start over. Every step should be editable without having to throw away other changes.

Today there are two main, viable options that fit those criteria: Raw workflows (for example using Lightroom), and Photoshop workflows.

Raw Workflow

This method uses Lightroom, Aperture, Adobe Camera Raw, Nikon Capture, Capture One, or any software that works directly with Raw images to do most of the work, with occasional forays into Photoshop to perform more complex tasks. All these Raw processors are non-destructive, which means that the original file is never modified, and all changes to the image's appearance are written as instructions in the file's metadata.

This workflow is viable only if the software can do most routine tasks. For me this includes dodging, burning, and curves, as every image needs some dodging or burning, and curves are the only way to have complete control over image contrast.

Even though I call this a Raw workflow, many of these programs work well with JPEGs also.

Photoshop Workflow

This method often starts with another program (anything from Lightroom to iPhoto) for editing, sorting, and making some basic adjustments, but uses Photoshop for most of the heavy lifting. Photoshop is the most powerful and sophisticated image-editing program available, and you may prefer to take advantage of it's power right away. This workflow is also a better choice if your other software can't do routine tasks like dodging and burning, or lacks curves. If you know you're going to take an image into Photoshop, it's better to make only minimal adjustments in other software, as this leaves you with more flexibility later. All you really need to do is get the white balance close, and make sure you're bringing as much highlight and shadow detail as possible into Photoshop. Some sharpening may also be needed for Raw images, or JPEGs with minimal sharpening applied in the camera.

Since Photoshop was not designed to be a non-destructive editor, you have to make it behave like one. This means using adjustment layers to keep all changes editable.

Simple Adjustments

Most Raw processors could easily
handle the simple adjustments
needed for this image—mostly
converting to black and white
and adding contrast.

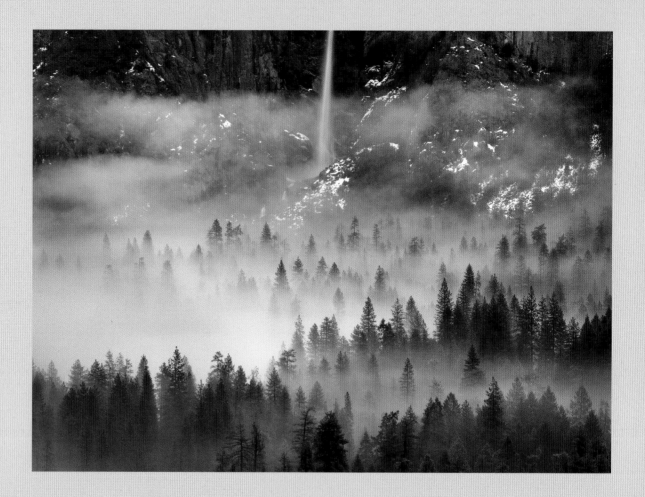

Choosing a Workflow

The advantage of the Raw workflow is that you
can use one tool for everything—editing, sorting,
keywording, and processing—without having to
switch between programs. Non-destructive editing
(which maintains all the original data) is also inherently
superior, even though Photoshop can be forced to
behave in a non-destructive fashion. Raw processors
can also be easier to learn than Photoshop.

The Photoshop workflow takes advantage of
Photoshop's tremendous power. Many tasks can't
be done in other programs, including perspective
cropping, serious retouching, making complex
selections, and combining two or more images.

There is no reason why you need to use one workflow
for every image. I use both; processing most images
in Lightroom, but moving some photographs into
Photoshop for jobs that Lightroom can't handle.

1
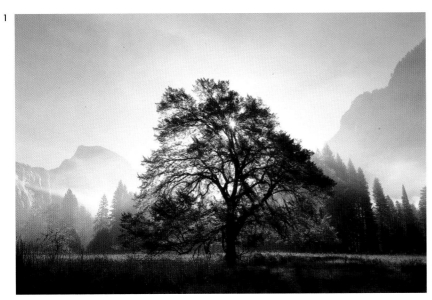

2
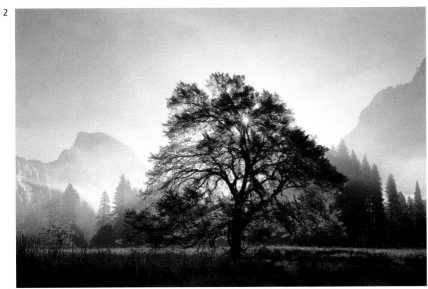

Perspective Cropping

1. Pointing a wide-angle lens upward caused the trees at the edges to lean in.

2. Photoshop's perspective cropping straightened the trees.

Combining Images for Depth of field

I blended five original images to expand the depth of field in this photograph, something that required Photoshop's power. Before bringing the Raw files into Photoshop I made minimal adjustments in Lightroom, making sure all the images had the same white balance, sharpening, contrast, etc.

As his materials and technique improved, Ansel Adams changed his darkroom interpretations. Moonrise, Hernandez on page 6 is a great example: he lowered the value of the sky over the years until it became nearly black. He wrote: "As months and years pass the photographer refines his sensibilities and may change the value relationships within an image according to his evolving awareness."

Over time I've changed the color balance and softened the contrast in this photograph of Bridalveil Fall. A master file should always be flexible—you should be able to modify any aspect of it without starting over.

The Master File

With either workflow the goal is to produce a master file—a file that contains all your adjustments and can be copied or exported for any use, including large prints, small prints, web, and email. There are four important principles to keep in mind with any master file:

Calibrate the Monitor

Without a properly calibrated monitor you may as well be blind. You're just guessing about the colors and tones, and how a print might look. You need a colorimeter—one of those puck-like devices that rests on the screen—and its accompanying software.

Keep the Master File Editable

This happens automatically with non-destructive applications like Lightroom or Aperture. If you use Photoshop, make all your adjustments on layers, and never flatten those layers in the master file. If you need to merge the layers to print, make a copy of the master file first.

Don't Resample the Master File

You can't resample the original file in non-destructive programs, so again this is not a concern with that workflow. With Photoshop, you should never resample the master file—that is, never increase or decrease the number of pixels. Resampling downward—decreasing the number of pixels—throws away information and valuable detail. Resampling upward—increasing the number of pixels—won't destroy information, but makes the file larger without adding detail. To produce a large print, make a copy of the master file before increasing the number of pixels.

Sharpen Conservatively

Every Raw file needs some sharpening, as do JPEGs made with low sharpening settings (see page 18). Files from some cameras need a lot of sharpening, some very little, so you have to experiment to find the optimum settings for your own model. Sharpening in non-destructive programs like Aperture or Lightroom is always editable, so if you overdo it you can make an adjustment later.

Be conservative about adding sharpening in Adobe Camera Raw, Nikon Capture, or any other application before bringing an image into Photoshop. You don't want to box yourself into a corner and have to start over. You can always sharpen a file after bringing it into Photoshop, but to retain flexibility you never want to sharpen the original background layer of a master file—you should always sharpen on a separate layer, or turn the background layer into a Smart Object. Some popular plugins like PhotoKit Sharpener add sharpening on a layer automatically.

This slight sharpening of the original Raw or JPEG image should not be confused with print sharpening. Most images need a bit more sharpening before printing, but this should be one of the last steps, after setting the print size and resolution, and should only be done on a copy of the master file, never on the master file itself.

RGB Working Spaces

The large half-oval shape represents all the colors visible to the human eye. The smallest triangle shows the colors included in sRGB, the largest delineates ProPhoto RGB, while the middle triangle represents Adobe RGB. sRGB is obviously a very small color space, but Adobe RGB isn't much bigger. ProPhoto RGB, on the other hand, includes almost all the colors in the visible spectrum.

RGB Working Spaces

When opening images in Photoshop you can choose a working space. The most common options are sRGB, Adobe RGB, and ProPhoto RGB.

What is an RGB working space? Colors in digital images are described by amounts of red, green, and blue. The working space defines which red, which green, and which blue. In practice this means that some color spaces include a wider range, or gamut, of colors than others. The accompanying diagram compares sRGB, Adobe RGB, and ProPhoto RGB. Adobe RGB encompasses a slightly wider range of colors than sRGB, but both are quite small. ProPhoto RGB includes almost all the colors the human eye can see.

The differences only become apparent with highly saturated colors. With a smaller color space, like sRGB or Adobe RGB, a brilliant red could be changed to the nearest equivalent within parameters of the color space, becoming a more faded red, or perhaps shifting to red-orange. These differences can't be shown in a book like this, but will be apparent with the best inkjet printers, all of which can reproduce colors beyond the gamut of sRGB or Adobe RGB. For that reason, I routinely use ProPhoto RGB. There is a potential pitfall, however: The 256 levels of an 8-bit file must be stretched further to cover the wide color gamut of ProPhoto RGB, creating more potential for banding or posterization. So in theory it would be better to use 16-bits with ProPhoto RGB; in practice, it's rarely an issue.

8 Bits versus 16 Bits

8 bits means 256 levels in each color channel—red, green, and blue—while 16 bits gives you 32,768 levels per channel. In theory, 16 bits is better. Thousands of steps should be able to render subtle gradations in tone or color better than a mere 256. In practice, it's hard to tell the difference, though if you are making heavy adjustments in processing then the extra "bit-depth" will become apparent.

Problems with 8-bit files are most likely to show up as banding or posterization—abrupt shifts from one tone or color to the next where there should be smooth transitions. This can happen at dusk, where light skies near the horizon should gradually become darker above, but sometimes break into distinct bands. Banding may also appear when making a big change, as when lightening a severely underexposed image.

Lightroom, Adobe Camera Raw, and most other programs that work directly with Raw files use 16 bits per channel. From there, you can bring an image into Photoshop with either 8 bits or 16 bits. The tradeoff is that 16-bit files are twice as large as 8-bit files and take longer to open, run filters, and save. Since I rarely see differences, I routinely use 8 bits per channel. Only if I encounter a problem, like banding, will I go back and try re-importing the file with 16 bits. If the photograph is grossly underexposed I'll correct that in Raw software before opening the file in Photoshop.

Banding in the Sky

This light-painted image shows slight banding or posterization in a dusk sky. I made minimal adjustments in Lightroom, then took the photograph into Photoshop with both 8 bits per channel and 16 bits per channel. Both show the same banding. This may be because the camera itself only used 10 bits per channel, or it may be a profiling issue. Either way, increasing the bit depth didn't solve the problem. While 16 bits is better in theory, differences can rarely be seen in practice.

Processing Order

Whatever workflow you choose, make it consistent. Do the same steps in the same order each time so that you don't forget anything vital. While an unusual image might require a different sequence, most can be approached in similar fashion. Here's an order that makes sense to me for Photoshop. With a non-destructive editing application like Lightroom the sequence can be more flexible—just don't forget something.

Crop
This is an important aesthetic choice that influences all the other decisions about an image, so I do this first.

Reduce Noise
If necessary, this should be done early. In Photoshop things get more complicated if you wait until after retouching. To retain flexibility, run noise-reduction filters on a copy of the background layer or turn the background layer into a Smart Object.

Retouch
Whether removing dust spots or a distracting telephone pole, I like to complete this odious chore early. In Photoshop it also makes sense to manipulate pixel layers before adding adjustment layers.

Convert to Black and White (optional)
It's better to convert to black and white before adjusting tonality.

Make Overall Tonal Adjustments
This means setting the overall brightness and contrast. Ignore small areas at this stage; make the image look good as a whole, knowing that small regions can be modified later. Since tonality affects color, leave decisions about saturation until later.

Make Overall Color Corrections (Color Images Only)
This includes overall color balance and saturation. Again, you're concerned with the overall image at this point, not specific areas.

Make Local Adjustments
Dodging, burning, and other local corrections should come after you've set the overall appearance.

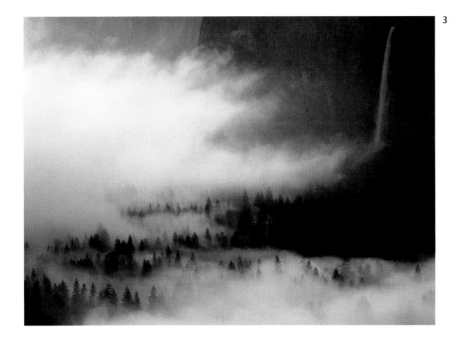

3

Adjust Contrast Before Color

1. Before adding a curve for contrast, the colors in this ice pattern appeared faded.

2. Increasing the contrast also boosted saturation. Since tonality affects color, it's usually best to adjust brightness and contrast first.

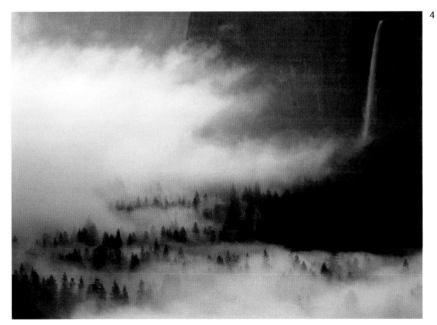

4

Make Overall Adjustments First

Bridalveil Fall is a focal point of this image (3 & 4), but a small part of the composition. I set the overall tonality for the clouds and trees (3), then lightened (dodged) the waterfall for the final picture (4).

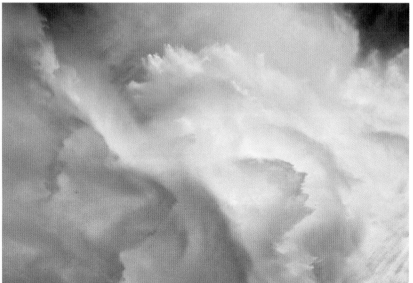

Cropping

When you compose a photograph, you put a frame around part of the world and invite people to look at it. The exact borders are critical. Check all the edges for distracting elements—bright spots, dark spots, or objects that are cut in half. The easiest way to remove such distractions is to crop them out. If that's not possible—if cropping them would eliminate other important elements—then you might try cloning out the offending object.

Eliminating Distractions

Any dark or light spot along the edge of a photo can become a distraction. The small dark spot in the lower-right corner of this Nevada Fall close-up (top) was easily cropped out to create the final image (below).

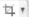 Cropped Area: ○ Delete ● Hide ☑ Shield Color: ☐ Opacity: 100% ▾ ☐ Perspective

Editable Cropping in Photoshop

Like every other adjustment, cropping should be editable. Later, if you decide you cropped too much, you need to be able to recover the lost areas without starting over. This happens automatically with non-destructive programs like Lightroom and Aperture, but it requires some finesse in Photoshop.

First, change the Background layer to a regular layer. This will allow you to hide the cropped area instead of deleting it, so that you can change your mind later. Go to *Layer > New > Layer From Background*, or just double-click on the layer name (where it says Background). Give this new layer a name.

Then select the Crop tool. Click the Clear button (in the Options bar at the top) to make sure that the Width, Height, and Resolution boxes are empty. If they're not, Photoshop will resample the image. After making an initial selection with the crop tool, choose Hide instead of Delete in the Options bar. Drag the edges of the

marquee to make your final crop and press Enter to finish. To see the whole image again at any time in the future, select *Image > Reveal All*.

Retouching

Photographers were manipulating images long before Photoshop. Local teenagers painted white rocks to spell out "LP" on the hills in Ansel Adams' Winter Sunrise from Lone Pine (see page 68). Adams spotted these letters out of his negative. He said, "I have been criticized by some for doing this, but I am not enough of a purist to perpetuate the scar and thereby destroy—for me, at least—the extraordinary beauty and perfection of the scene."

Ethics aside, retouching is far easier in the digital age, but it still requires skill and a flexible approach.

Editable Retouching in Photoshop

1. In cloning out the lens flare from this image I kept the retouching editable by cloning onto a blank layer. First I clicked on the New Layer icon at the bottom of the Layers Palette. This created a blank, or transparent, layer.

2. Next I chose the Clone Stamp tool and set the mode to Normal, the Opacity to 100%, checked "Use All Layers," and selected the "Ignore Adjustment Layers" button.

3. After cloning out the lens flare I turned off the background layer to show the "patches" where pixels were copied from the background layer onto the transparent layer. With the Eraser tool I could easily remove one patch while leaving the other retouching intact.

4. The final image with the lens flare removed.

1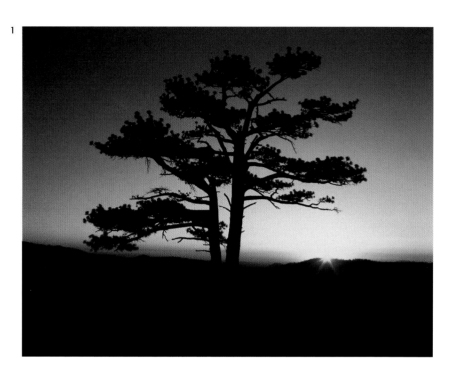

2

3

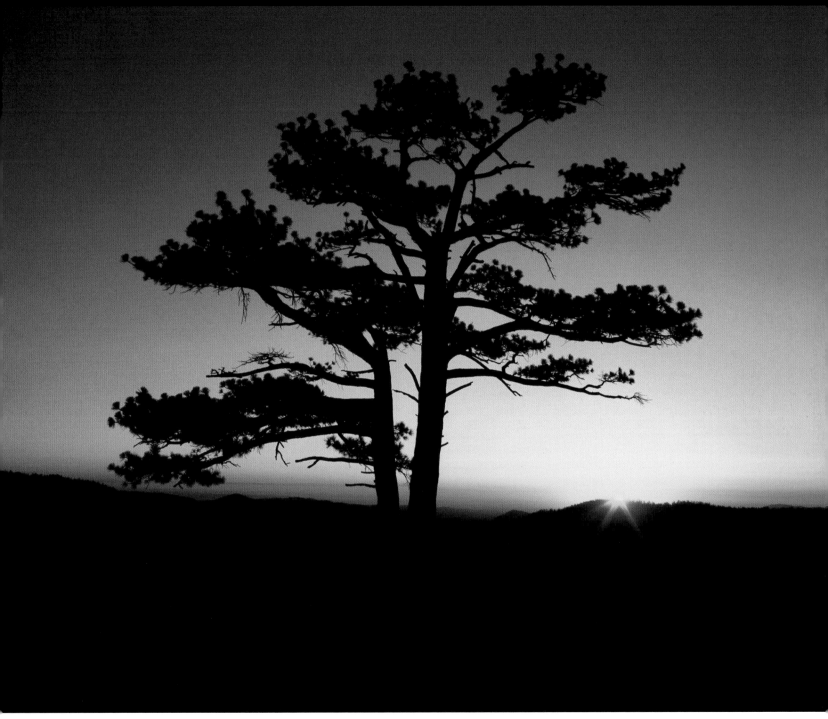

1

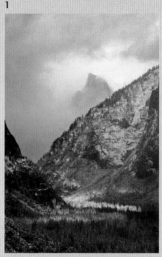

Grayscale Mix	
Red	– 29
Orange	– 50
Yellow	– 38
Green	– 26
Aqua	– 4
Blue	= 13
Purple	= 15
Magenta	= 4
	Auto

2

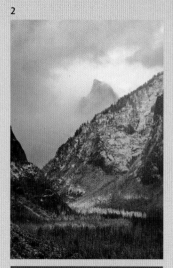

Grayscale Mix	
Red	+ 4
Orange	+ 25
Yellow	+ 52
Green	+ 25
Aqua	0
Blue	– 25
Purple	– 19
Magenta	0
	Auto

3

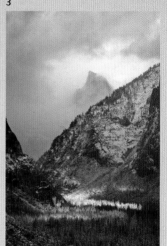

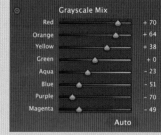

Grayscale Mix	
Red	+ 70
Orange	+ 64
Yellow	+ 38
Green	+ 0
Aqua	– 23
Blue	– 51
Purple	– 70
Magenta	– 49
	Auto

4

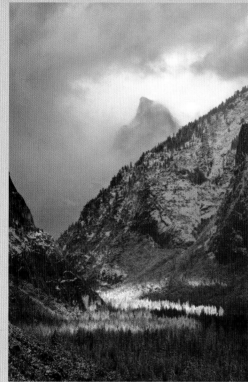

Converting to Black and White

As I mentioned in Chapter 1, you have far more control over black-and-white images if you capture them in color, then convert them to black and white in software. Photoshop, Lightroom, and Camera Raw now all have similar controls: In Photoshop, make a Black-and-White Adjustment Layer; in Lightroom or Camera Raw, modify the Grayscale Mix.

These tools allow you to adjust the relative brightness of individual colors: to make the reds lighter or the blues darker, for example. It's like being able to choose which colored filter to use after the fact, but even more powerful. You can separate colors that would be too close together for any conventional filter.

Choosing a Digital Filter

1. The original image Half Dome shows warmer colors in the sunlit areas, cooler shades in the shadows.

2. Adding the digital equivalent of a blue filter produced a flat rendition, as it lightened the blue shadows and darkened the golden sunlit areas.

3. Settings comparable to a yellow filter lightened the warmer sunlit areas, darkened the shadows, and generated more snap.

4. The default equivalent of a red filter created the strongest contrast.

1

2A

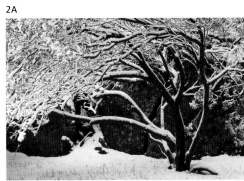

2B

3

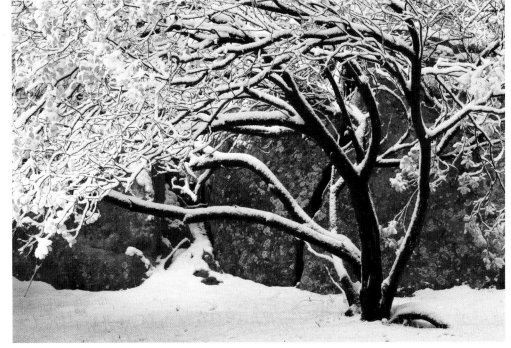

Separating Similar Colors

1. In this example from Chapter 1 (page 31) the challenge was to separate the orange trunk and the yellow-green rock into distinct shades of gray.

2. In Photoshop I made a Hue/Saturation Adjustment Layer and changed the color of the trunk to magenta.

3. A Black-and-White Adjustment Layer lightened the yellows and greens while darkening reds and magentas.

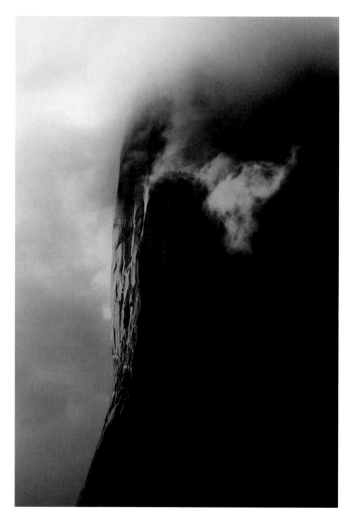

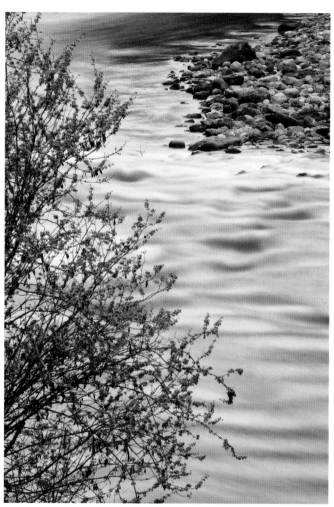

Sunset White Balance

For outdoor images taken with natural light, the color temperature should not be lower than around 5000K, 4800K at the lowest. Midday sunlight is about 5000K, and shade is higher (bluer). While the light at sunrise or sunset is warmer, you don't want to correct for this—you want it to be warm. So sunrises, sunsets, and anything lit by direct sunlight should have a color temperature setting of around 5000K. Higher numbers are for shade, overcast conditions, and dusk, while lower numbers are for images taken under tungsten lights. The color temperature of this El Capitan photo was set to 5200K in Adobe Camera Raw.

Dusk Color Temperature

When exposing images in difficult lighting conditions, such as dusk or mixed (natural and artificial) light, I sometimes put a white card into one image, then remove it for the rest of the shoot. Then I can use the Eyedropper tool in Lightroom or Camera Raw to click on that white card, set the white balance, and apply that same setting to all the other images. I knew finding the right color temperature could be difficult when I made this photograph of a redbud along the Merced River at dusk, so first I took a photo of a white card, then used the Eyedropper tool in Lightroom. The corrected color temperature, at 14,080K, was well beyond the range you might imagine.

1

2

Color Temperature Correction

The camera's automatic white balance missed the mark more than usual, leaving this photo of Tenaya Creek too blue (1). The Color Temperature slider in Lightroom quickly cured this problem, allowing me to drag the mouse until the color looked good (2).

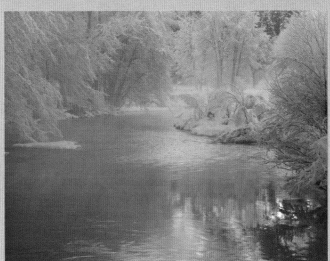

Adjusting White Balance

This is usually a simple matter with Raw images. Most Raw processors have a color temperature slider. Just move the slider left or right to make the photograph cooler (more blue) or warmer (more yellow). Even if I plan to take an image into Photoshop I'll adjust the white balance in Lightroom or Camera Raw first, as this is more straightforward than doing it in Photoshop.

Retaining Color Contrast

The best color balance is not necessarily neutral; sometimes a warmer or cooler tint looks better. I left the shadows blue in this wintry scene along Yosemite's Merced River to keep the contrast between the shaded snow and warm reflections of sunlit cliffs.

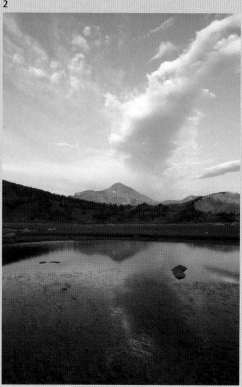

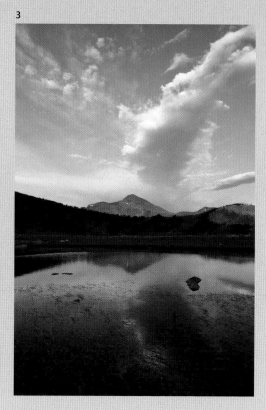

Black Points, White Points, and Contrast

*"Life is not all highlights; there must be halftones
 and shadows as well."*
—Edward Weston

Initial Contrast

Ansel Adams said, "As the final step in evaluating the
negative... it is best to use a soft grade of paper to
make a proof or first print. The print may be visually
flat, but the purpose is to reveal all the information
available in the negative, especially the texture and
detail in the extreme values."

The same principle applies to digital images. The
default settings on most Raw processors add contrast,
so I always reset these defaults so that the curve is
straight and contrast settings are at zero. This makes
many images initially look flat, but that's easily fixed,
and it's important to see the actual highlight and
shadow detail in the Raw file.

If the photograph still has too much contrast—if the
histogram shows washed-out highlights or black
shadows—try to recover detail in those areas before
proceeding further. Many applications have tools
for restoring highlight and shadow detail, including
Recovery in Adobe Camera Raw and Lightroom,
and Highlight/Shadows in Photoshop.

Revealing Highlight Detail

1. The default settings in Lightroom
added enough contrast to wash out
detail in the brightest clouds.

2. Removing this extra contrast
revealed texture in the clouds.
The image looks flat, but as long
as there's information in the darkest
and lightest areas there's something
to work with.

3. The final processed image is darker,
with more contrast, but has detail in
both highlights and shadows.

1

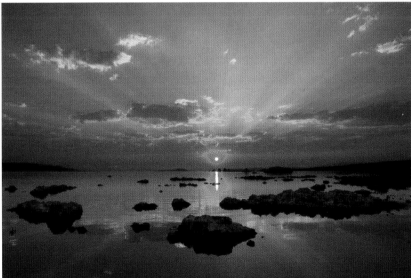

2

Black Points and White Points

Placing the black and white points is one of the most important aesthetic choices a photographer makes. An image with deep blacks and bright whites will have more punch, more snap, than one without them. But some photographs need a softer touch. Here's Ansel Adams' view: "A note of pure white or solid black can serve as a 'key' to other values, and an image that needs these key values will feel weak without them. But there is no reason why they must be included in all images, any more than a composition for the piano must include the full range of the eighty-eight notes of the keyboard. Marvelous effects are possible within a close and subtle range of values."

Observe that he said, "A note of pure white or solid black..." Large patches of solid black or blank white rarely look good. Small areas are all that are needed for most images, and some don't need any. Black-and-white photographs seem to tolerate small sections of pure white better than color images. For some reason, even small spots of blank, washed-out white seem unnatural in color, while they look fine in black and white. Perhaps it's the extra level of abstraction inherent in the monochrome palette?

1. Low Contrast

Not every image needs a full range of tones. The soft, ethereal quality of this smoky scene would have been ruined by deep blacks or bright whites.

2. High Contrast

This dramatic scene needs the impact provided by small areas of pure black and white.

Levels and Curves

There are two main tools for adjusting overall image contrast: levels and curves. Curves are far more powerful. In fact, curves are the most powerful processing tool in the digital photographer's arsenal. Master them and you're on your way to mastering the digital darkroom.

With either levels or curves in Photoshop, make sure you use adjustment layers to keep your changes editable.

4

5
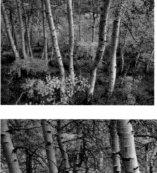

6
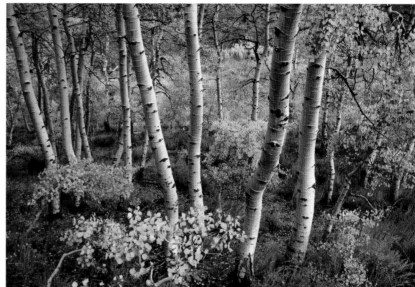

1
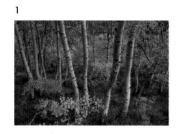

2
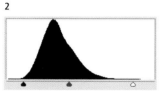

3
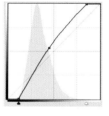

Comparing Levels and Curves

1. The original Raw file of these autumn aspens shows white balance adjusted but no contrast added.

2. With levels there are three controls—a black point, a white point, and a midtone slider. Pushing the black point to the right increases blacks; everything in the histogram to the left of the black point becomes pure black. Pushing the white point to the left increases whites; everything in the histogram to the right of the white point becomes

pure white. The middle slider sets the midtone value—the overall brightness of the image. Here I increased the contrast by moving the black point to the right and the white point to the left. This clipped both highlights and shadows—made some small shadow areas pure black, and some small highlights pure white. I also moved the midtone slider to the left, lightening the image overall.

3. For comparison, I made the same adjustments with curves instead of levels. With curves, moving the bottom-left point to the right (keeping it along the bottom) is the equivalent of moving the black point to the right with levels. Moving the top-right point to the left (keeping it along the top) is the same as moving the white point to the left with levels. Moving the midpoint of the curve up or down is like moving the middle slider with levels left or right. Here I moved the black and white points to increase contrast, and lightened the midtones—just as I did with levels.

4. This image now has more contrast, but at the expense of some highlight and shadow detail.

5 & 6. With curves you have more than three points of control, giving you far more power. The steeper the line of the curve, the more contrast. Here I increased the midtone contrast (note the steep line in the middle of the curve) without clipping either highlights or shadows—the black and white points were kept outside the brightest and darkest points of the histogram. The photograph has more overall contrast, without sacrificing detail in the extreme values.

1A 1B 2A

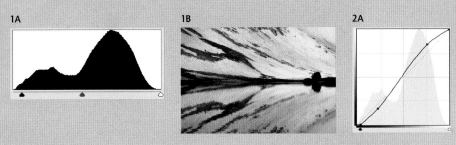

2B

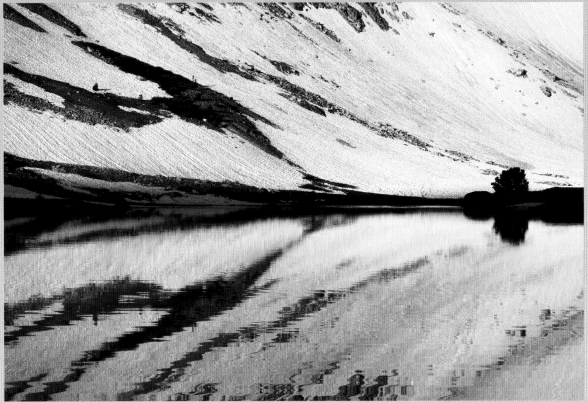

S-Curves

1A & B. This image fills the whole histogram, so there is no room to move the black point or white point without clipping either highlights or shadows, limiting the amount of contrast that can be added with levels. Using Levels, I pushed the black point to the right, turning some shadows pure black, and moved the midpoint slider to the left, lightening the midtones. Changing the white point would have washed out important highlights.

2A & B. Curves are more flexible. Here I pushed the black point to the right just enough to create small areas of pure black, left the white point alone to avoid clipping highlights, then placed two more points to make an S-curve. The S-curve increased the midtone contrast and lightened the snow without losing highlight detail. The result is a brighter, livelier image.

I use some kind of S-Curve on at least 95 percent of my photographs. An S-curve can increase the overall contrast without sacrificing highlight or shadow detail.

1. Low-Contrast Image
1A. Before curve
1B. After curve
With a low-contrast image—where the pixels don't fill the whole histogram—you can make sizable moves with the black and white points without clipping highlights or shadows. Here I moved both the black and white points, but kept them outside the image pixels to avoid clipping. A slight S-curve increased the midtone contrast.

2. High-Contrast Image
2A. Before curve
2B. After curve
This image already had plenty of black (note the spike on the left side of the histogram), while the highlights were almost touching the right edge of the histogram, so I couldn't move the black or white points without losing important highlight or shadow detail. A gentle S-curve enhanced midtone contrast and lightened the image overall.

3. Darkening S-Curve
3A. Before curve
3B. After curve
To darken an image, while also increasing contrast, place points at about the ¼ and ¾ points of the curve. Pull the ¼ point down, but leave the ¾ point near its original location. Note that the middle of the curve now passes below its original, straight-line position, showing that the midtones have been darkened.

4. Lightening S-curve
4A. Before curve
4B. After curve
To lighten an image while also increasing contrast, again place points at about the ¼ and ¾ points of the curve. This time leave the ¼ point near its its original spot but push the ¾ point up. The middle of the curve now passes above its original position, indicating brighter midtones.

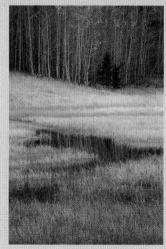
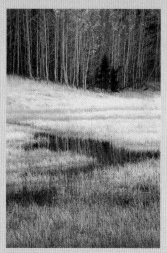

1A 1B

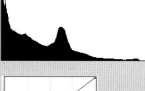
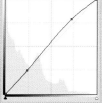
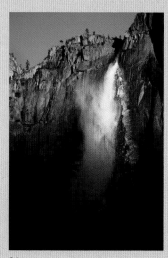
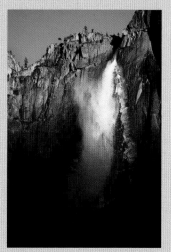

2A 2B

3A

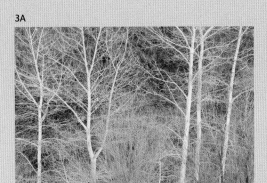

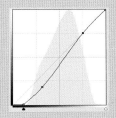

3B

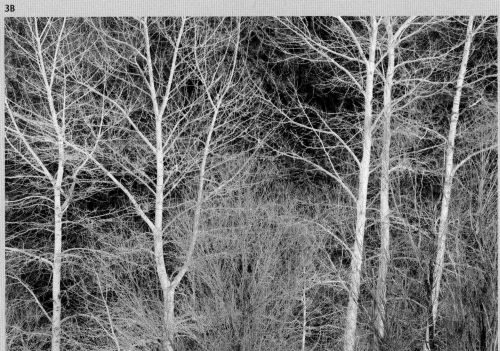

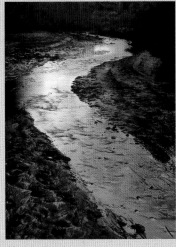

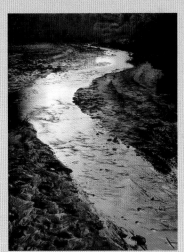

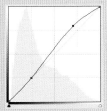

4A 4B

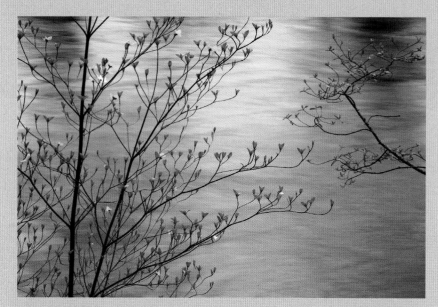

Adjusting Color

Color Balance

After setting the white point, black point, and overall brightness and contrast, some fine-tuning of the color balance may be necessary. If you're using the Raw workflow, you can simply tweak the white balance slider. In Photoshop, make another Curves Adjustment Layer, then select one of the individual channels—either red, green, or blue. It helps to remember the opposites: red and cyan are opposites, as are green and magenta, blue and yellow. So if you want more magenta, subtract green. If you want less magenta, add green, and so on.

Vibrance and Saturation

Saturation is the most abused tool in digital imaging. Some people feel that if a little saturation is good, more is better. But while extra color intensity can give a photograph life, too much will strangle it. There's a fine line between a luminous print and a garish one.

Photographic color has long been controversial. Eliot Porter wrote, "I have been criticized for the distorted and artificial colors in my photographs... however, the colors in my photographs are always present in the scene itself, although I sometimes emphasize or reduce them in the printing process. To do this is no more than to do what the black-and-white photographer does with neutral tonal values during the steps of negative development and printing."

Most Raw files are rather flat, and can benefit from a slight increase in overall saturation or vibrance. Here a moderate boost in saturation added intensity to the reflection in the final image (below).

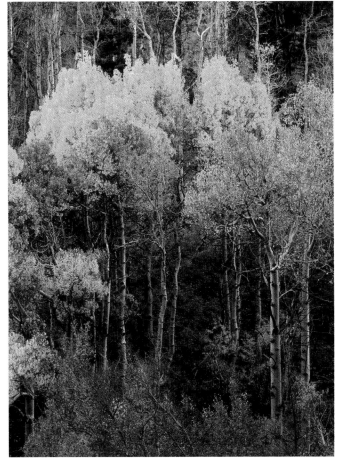

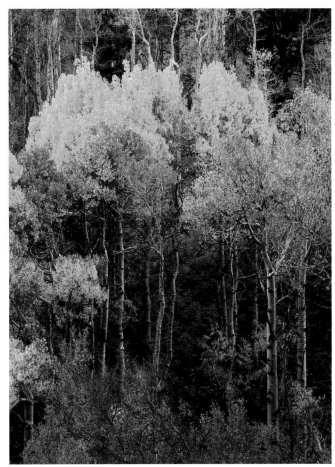

Color Balance Curve

This is a typical curve for correcting color balance in Photoshop. The photograph, taken in the shade, was too blue, so I selected the blue channel, added a point in the middle of the curve, and dragged highlights, shadows, and midtones down to reduce the blue. Small moves make a big difference. I usually make a slightly greater shift in the midtones than the highlights or shadows. When adjusting an individual color channel, rather than the composite RGB curve, it's okay to change the output levels—to put the black and white points along the sides of the grid. But it's not okay to have a crossover—to move shadows in one direction and highlights in another—unless you want to produce strange effects. Individual channels are not the place for an S-curve.

Dodging and Burning

Nature rarely provides perfect illumination. Dodging and burning allows photographers to shape the light into something more ideal.

When people look at photographs, they usually focus their attention on bright spots while ignoring dark areas. Dodging and burning are ways of controlling the viewer's eye. Does the image have a distracting highlight? Then darken it. Is an important focal point too dark? Make it brighter.

Flexible Dodging and Burning in Photoshop

The lower-right corner of this image (1) is too bright—it pulls your eye away from the colorful leaves. Photoshop's Dodge and Burn tools aren't flexible enough—the changes aren't easily editable. Instead, create a Curves Adjustment Layer (3) and pull the midpoint of the curve up and left to lighten (dodge), or down and right to darken (burn). Press Command-I (Mac) or Control-I (Windows) to invert the layer mask. Now select the Brush tool and choose a large, soft-edged brush. Make sure the foreground color is white, and the opacity set to 100%. Click and drag to paint over the portion of the image you want to change. Here I pulled the curve down and painted over the lower-right portion of this photo to darken it (2).

1
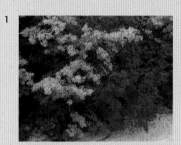

2

3

4
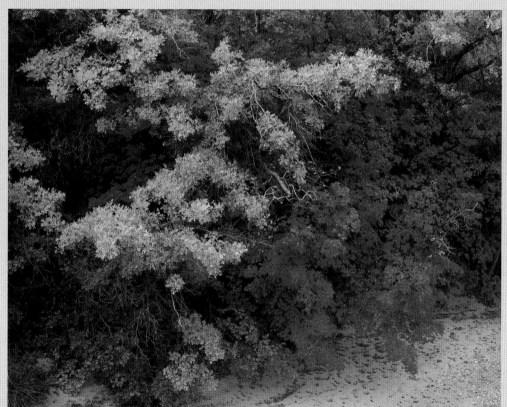

Increasing Contrast

You can use a similar procedure to increase contrast. The trees near the bottom of this photo (1) are barely visible; they need more contrast to help them stand out. I made a new Curves Adjustment Layer (3) with an S-curve for contrast, inverted the layer mask, then painted with white over the lower-center and right portions of this photo (2).

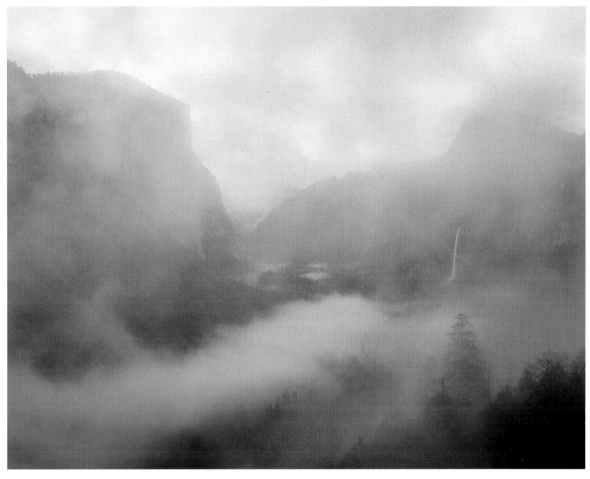

1

2

3

1

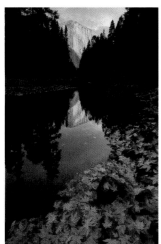

2

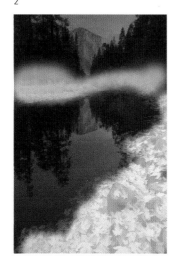

El Capitan Dodging and Burning

The first version of this El Capitan photo (1) was adjusted for overall brightness, contrast, and color, but has not been dodged or burned. The leaves in the foreground are too dark—they need to draw the viewer's eye more—while El Capitan and its reflection look washed out. In the finished image, El Capitan and its reflection have been darkened, enriching their colors, while the leaves and river bank were lightened to make them more prominent. The diagrams show the dodging (2) and burning (3) masks—the area of El Capitan and its reflection that was darkened, and the section of leaves and river bank that was lightened.

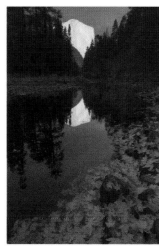

3

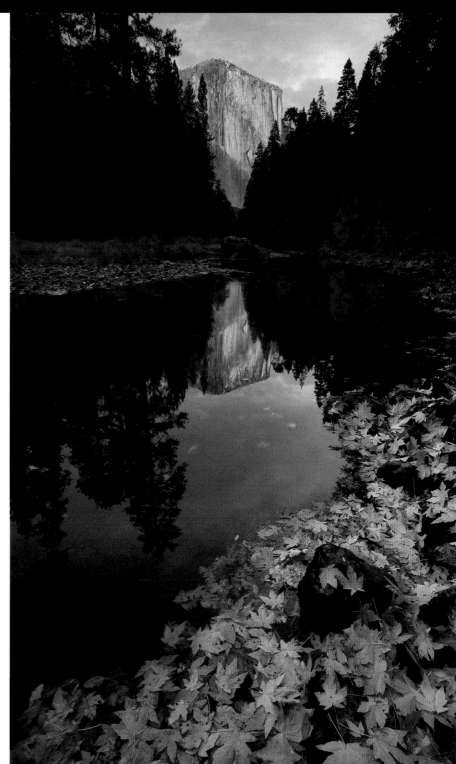

1

2

Digital Graduated Filter

A slight variation of these dodging
and burning techniques can imitate
the effect of a graduated neutral-
density filter, but with more control.
Some programs, like Lighroom and
Adobe Camera Raw, have built-in
graduated filter tools. In Photoshop,
start by making a Curves Adjustment
Layer. In this example, since I wanted
to lighten the foreground, I placed a
point in the middle of the curve and
dragged it up and to the left. Next,
I selected the Gradient Tool and chose
the Linear Gradient and the "Black,
White" preset. Then I clicked and
dragged from top to bottom through
the middle of the image—not the
whole photograph, just the transition
area from light to dark (2), the
graduated part of the "filter."
Dragging a short distance creates an
abrupt transition—a hard-edged filter
(3). Dragging a long distance creates
a gradual transition—a soft-edged
filter. (If you don't get it right the first
time, just click and drag again. If you
go the wrong way, just drag again in
the opposite direction.)

3

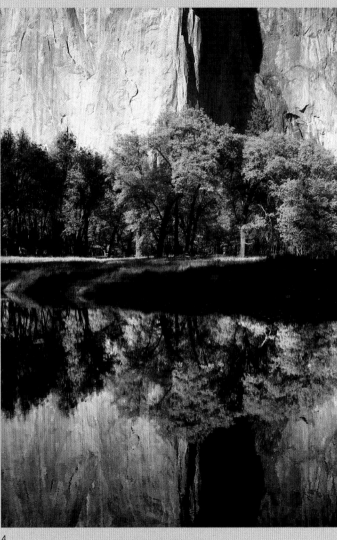

4

1

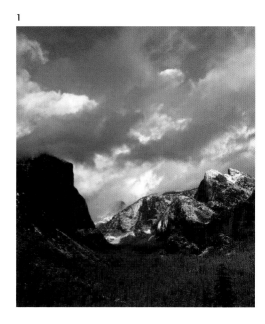

Precision Dodging and Burning

1. Yosemite Valley before dodging and burning.

2. I added a Curves Adjustment Layer with a slight S-curve, inverted the layer mask (Command-I for Mac, Control-I for Windows), and painted with white over the sky to add contrast to the clouds.

3. Another Curves Adjustment Layer lightened Bridalveil Fall.

4. A third Curves Adjustment Layer brightened El Capitan.

5. I lightened and added contrast to the trees in the middle.

6. A fifth curve brightened and increased contrast in the entire foreground except a few bright sunlit areas underneath Half Dome.

7. The final image.

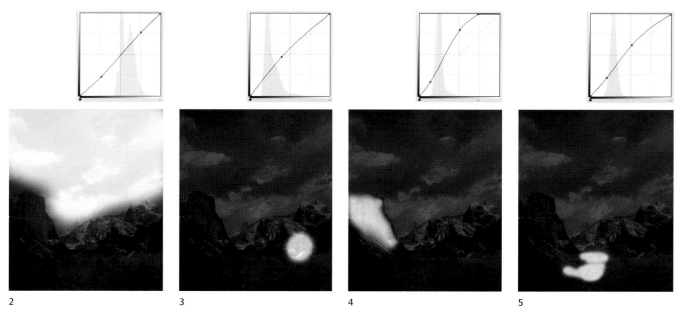

2 3 4 5

6

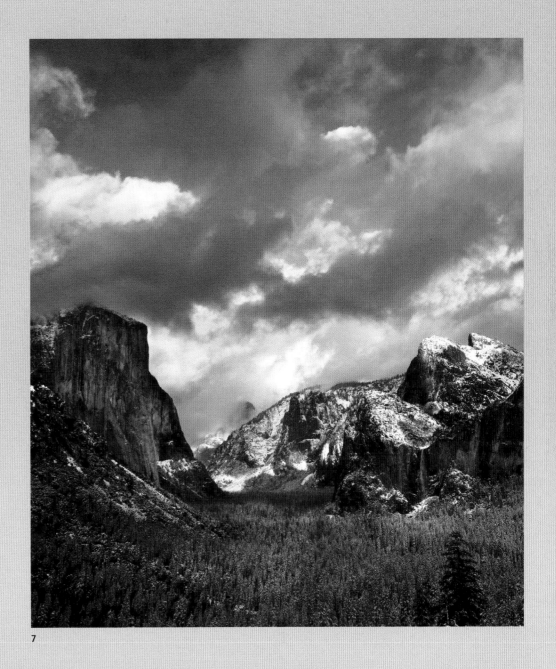

7

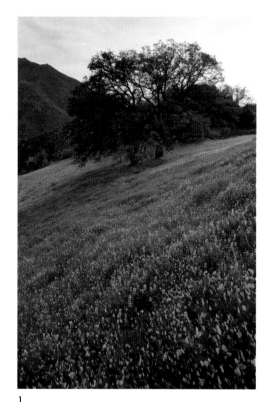

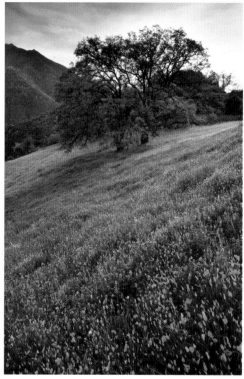

1

2

Sierra Foothill Flowers

1. HDR
2. Exposure Blend

With reduced development Ansel Adams was able to capture highlight and shadow detail in high-contrast scenes, but this could lead to flat, mushy areas in the midtones. The same problem confronts digital photographers using HDR software. Too much tonal compression can reduce local contrast and produce a lifeless image.

Expanding the Contrast Range

Digital photographers have unprecedented control over the contrast in their images. By combining exposures, it's possible to capture detail throughout any scene, no matter how great its dynamic range. The software tools for merging these exposures get better every year, yet it's still a challenge to make these images look natural and carry the right emotional impact.

HDR versus Exposure Blending

HDR, or High Dynamic Range imaging, uses software algorithms to combine different exposures to capture detail in highlights and shadows. It's usually a two-step process. First, the varied exposures are combined into a 32-bit HDR image. Since the dynamic range of this image exceeds that of computer monitors or printers, a second step, called tone mapping, is required to compress the tones into a usable range. The most popular HDR software today is Photomatix, but there are many others, including an HDR mode in Photoshop.

HDR can be used to create surreal effects, but here we're concerned with creating natural-looking images of high-contrast scenes—the digital equivalent of Zone System contraction.

Exposure blending uses different pieces of two or more images to display a wider range of contrast than would be possible with one image. This could be as simple as using the sky from one image and the foreground from another, or could involve merging pieces of many images. There are automated methods, such as the Exposure Blending option in Photomatix and the Auto-Blend Layers tool in Photoshop, or you can manually combine images in Photoshop using layers and layer masks.

The best method depends on the image. I find that exposure blending usually produces more natural-looking results than HDR, but there are exceptions, so I often try both techniques. For automated

Tunnel View

1. Photoshop
2. HDR

The first image was assembled manually in Photoshop from five separate exposures; the second blended the same original images using Photomatix HDR with the "Detail Enhancer" method of tone mapping. With both versions I converted the images to black and white, adjusted contrast, and added some dodging and burning. In this case HDR retained more local contrast, especially in the clouds, resulting in a more dynamic photograph.

exposure blending Photomatix is consistently excellent, but I can usually do a little better by merging the images manually in Photoshop. But this takes more time, skill, and experience.

HDR seems to work best when bright and dark areas are distributed evenly across the scene. Exposure blending is usually a better choice when part of an image is distinctly brighter than another, as when combining a bright sky with a dark foreground. It's possible to use both: you can start with an HDR merge, then blend that image with one of the original exposures in Photoshop, as I did with the photographs on page 13.

Local Contrast

In Chapter 1, on pages 50-51, I showed the four original exposures used to make both these composites. Here the first versions (1) were blended using Photomatix software in its HDR "Tone Compressor" mode. It succeeded in retaining detail in the both highlights and shadows, but the midtones—especially the flowers— appear flat and lifeless. The second images (2) were created with Photomatix's "Exposure Blending" mode. This is not true HDR, but an automated way of blending pieces of the original images—like using using layer masks in Photoshop, only requiring less skill. This method retained all the local contrast in the bottom two-thirds of the both images because the blending only occurred near the tops. The result is a crisper, livelier photograph. Blending images with layer masks in Photoshop could yield even better results.

1

2
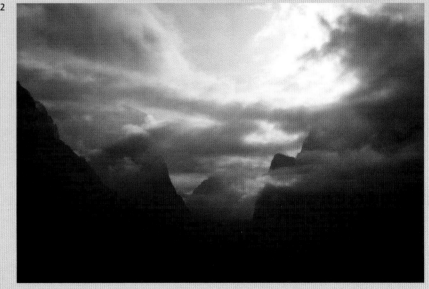

Manually Combining Exposures in Photoshop

The basic techniques for combining different exposures in Photoshop are similar to the dodging and burning methods described on pages 134-139. Both involve painting on layer masks, but instead of selecting part of an adjustment layer, you're hiding or revealing portions of a pixel layer.

Whether using Photoshop or HDR, make sure all the original images receive identical processing—the same white balance, contrast, etc.—before blending them.

1. Lighter original
2. Darker original
3. Layer mask
4. Final image

This image of Three Brothers provides an easy starting point. First I opened both of the original images in Photoshop, then selected the Move tool and dragged one image on top of the other while holding down the Shift key. Holding the Shift key aligns the two images precisely on top of each other. If the images are not aligned—if the camera was moved between exposures, for example—select both layers and choose *Edit > Auto-Align Layers*.

With the darker layer on top and selected (highlighted), I clicked on the Add Layer Mask button at the bottom of the Layers Palette. Next, as when dodging and burning, I inverted the layer mask by pressing ⌘-I (Mac) or Control-I (Windows). This made the layer mask black, hiding the darker top layer and revealing all of the lighter bottom layer. Then I selected the Brush tool, chose a large, soft-edged brush, made the foreground color white, and simply painted over the sections that were too bright and appeared overexposed. Painting with white allowed parts of the darker layer to become visible and override the lighter layer. The end result was a seamless blending of the two images.

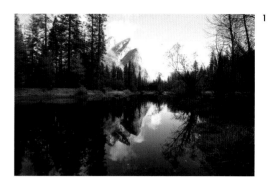

1

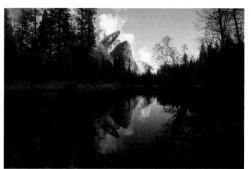

2

3

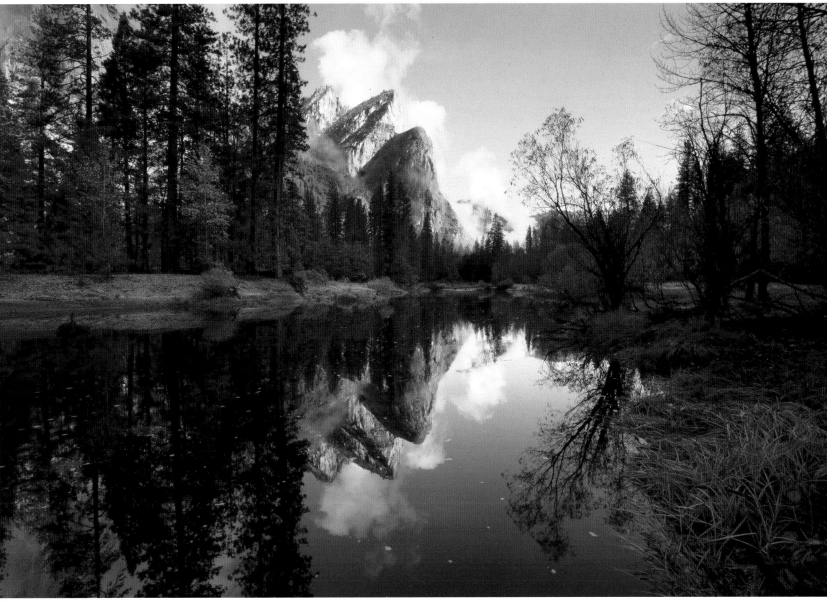

4

1

2

5

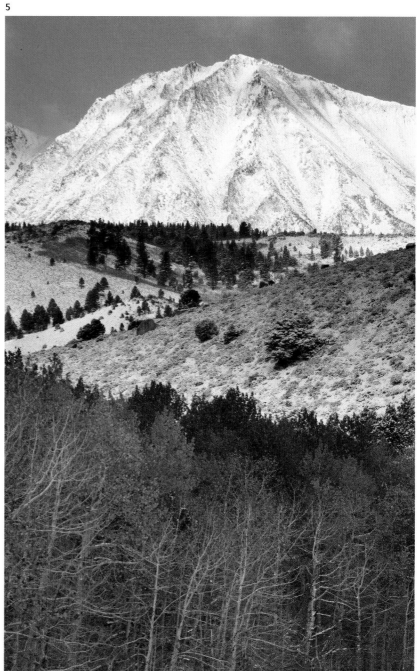

3

4

Gradient Blend

1. Dark original
2. Light original
3. Dragging the gradient
4. The resulting layer mask
5. Final image

Here's another simple blend, this time using the Gradient Tool to imitate the effect of a graduated neutral-density filter. This is similar to the technique described on page 137, but sometimes it's better to blend two images (1 & 2) rather than lighten part of one, as pulling detail out of dark shadows can reveal noise.

I started by shift-dragging one image on top of the other, as in the previous example. Here I put the darker image on top, then added a layer mask to the top layer. Next, I selected the Gradient Tool, chose a Linear Gradient with the "Black, White" preset, then clicked and dragged from bottom to top through the transition area (3). This made the layer mask (4) white on top and black on the bottom, with a gradual transition in between, so that the top section of this layer was visible but the bottom was masked off, allowing this part of the other, lighter layer to show through.

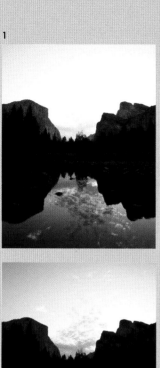

1

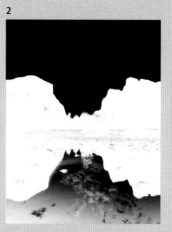

2

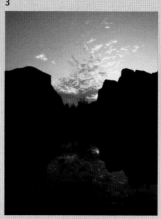

3

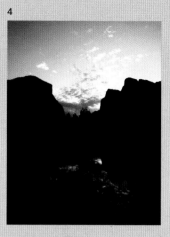

4

5

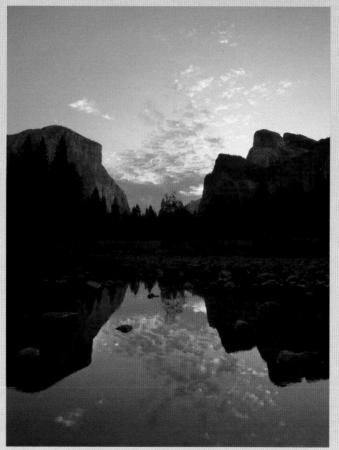

6

1. Top layer
2. Top layer's mask
3. Middle layer
4. Middle layer's mask
5. Bottom layer
6. Final image

In this more complex example I blended three exposures using the Color Range tool to create the layer masks.

I began by putting the middle exposure (5) on the bottom, the darkest layer (3) above that, and the lightest layer on top (1). Next I used the Color Range tool to select just the darkest areas—mostly the rocks and trees (2). With that selection active and the top layer highlighted, I clicked on the Add Layer Mask button at the bottom of the Layers Palette. Next I used the Color Range tool again, this time selecting the lightest pixels (4)—mostly the sky. With the middle layer highlighted I clicked the Add Layer Mask button again. These two steps essentially revealed the dark areas from the lightest exposure and the light areas from the darkest exposure, leaving some middle areas of the bottom layer (the middle exposure) showing through. Using Photoshop's Brush tool I manually modified the layer masks to smooth some of the transition areas to create the final result (6).

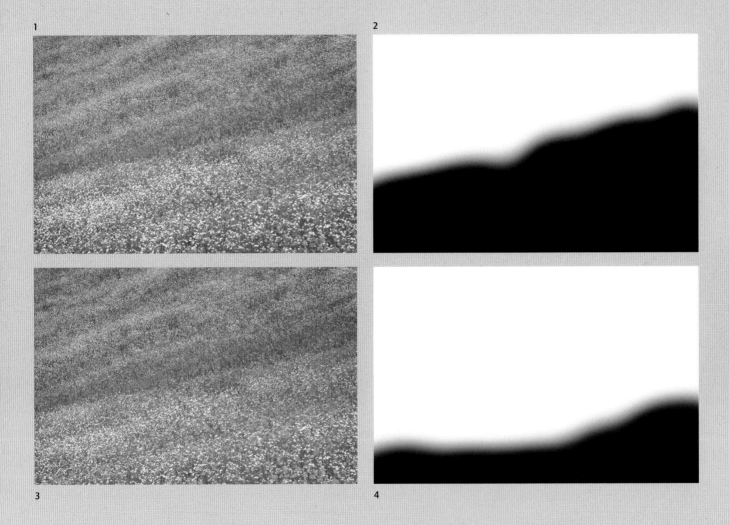

1

2

3

4

Expanding Depth of Field

Even at your smallest aperture it's not always possible to get everything in focus. The landscape masters of the past used the swings and tilts of their view cameras to change the plane of focus and achieve greater depth of field. With a digital SLR you can combine two or more images to keep everything sharp.

There are automated solutions for combining images for greater depth of field, including the Auto-Blend Layers option in Photoshop and several plug-ins. While these tools will undoubtedly keep improving, for now I get better results combining the images by hand in Photoshop.

5

6

1. Top layer
2. Top layer's mask
3. Middle layer
4. Middle layer's mask
5. Bottom layer
6. Final image

I blended these three images—one focused on the foreground, one on the background, and one in the middle—using layer masks in Photoshop. I put the layers in order from back to front—the layer focused on the background on top (1), and the layer focused on the foreground on the bottom (5). Next I added a layer mask to the top layer (2), selected the Brush Tool and a large, soft-edged brush. I chose black as the foreground color and simply painted over the out-of-focus areas—basically the bottom half of the image. This masked off those out-of-focus regions and allowed the sharper, in focus portions of the middle layer to show through. Next I added a layer mask (4) to the middle layer, and again painted with black to mask off the out-of-focus areas—mostly just the lower-right corner—allowing the sharp sections of the bottom layer to show through.

Printing

A well-crafted print is the ultimate expression of the photographer's art. Most of the work in making a digital print is done while preparing the master file, but a few essential steps remain, starting with choosing the printer and paper.

Printer Options

Digital/Chemical Hybrids

These printers, known by commercial names like Lambda, LightJet, and Chromira, use either lasers or LED lights to expose a digital file onto traditional, chemically-processed photographic papers. They are expensive, so you'll only find them at photo labs or service bureaus. Since the end result is an actual photographic print, these machines are good choices for creating a classic photographic look. The main drawback to using a lab for print output is that it's difficult to make accurate proofs. A reflective print is so different from a backlit screen that even the best monitor, accurately calibrated, can only provide a rough approximation of what the final print will look like. For critical work the only solution is to send proofs to the service bureau so they can be output on the actual device to be used for the final print, a potentially time-consuming and expensive process.

Inkjet Printers

These are by far the most popular digital printers today, and for good reason. They make beautiful prints, and are relatively inexpensive, giving photographers the opportunity to have a high-quality printer in their own home. To serious print-makers there is no substitute for experimentation and the ability to make many proofs in a short period time. The quality of the best inkjets is universally high, but there are differences. The manufacturers tend to promote features and statistics that are unrelated to print quality. The best test is a hands-on trial where you can print your own images and compare the results. Ask your friends if you can use their printers, or send files to a service bureau that uses a model you're interested in.

To render subtle gradations in tone with black-and-white prints, an inkjet printer should have black ink, of course, plus at least two gray inks. You may also want to look into specialized ink sets for black and white. Some third party manufacturers sell ink-and-software combinations that convert printers into dedicated black-and-white output using four, six, or more shades of black and gray.

Here are some other things to look for.

Blacks

While not all images need to have pure black in them, those that do benefit from having the deepest, darkest blacks possible. While not every Ansel Adams print contains pure black, the ones that do have a richness that only deep blacks can provide—something that Adams always strove for.

Color Gamut

How does the printer deal with highly saturated colors? Some printers do better with certain colors than others. Consider both the richness of the colors and the tonal separation in saturated areas. Do you see nice subtle gradations in tone, or large blotches of one color?

Gradations of Tone and Color

You should see smooth gradations in tone and color throughout the print, without banding or obvious dot patterns. Pay particular attention to the highlights and shadows to see how well the tones separate—whether you can see distinct values in these areas or whether they tend to pool into solid areas of black or white.

Bronzing and Gloss Differential

With glossy or semi-gloss papers hold the print at an angle to the light to see whether it has bronzing—a bronze sheen—in the dark areas. You may also see "gloss differential," where the print surface is shinier in the dark areas. To me, gloss differential is not as objectionable as bronzing, but it's a matter of degree.

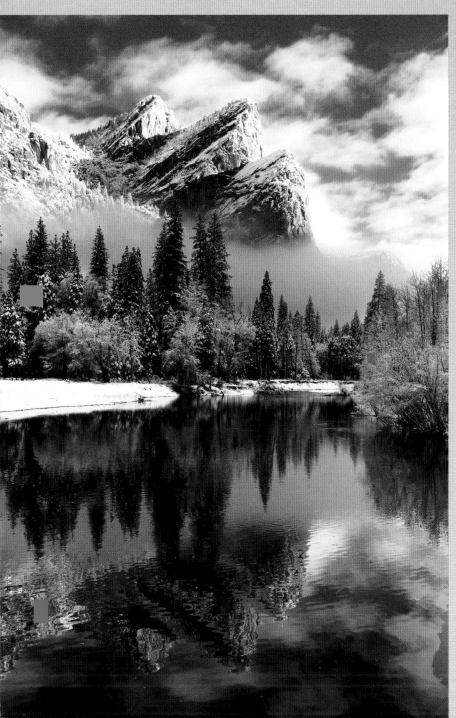

Print Quality

A good photo printer needs to be capable of rendering deep blacks, subtle gradations in tone, and highly saturated colors.

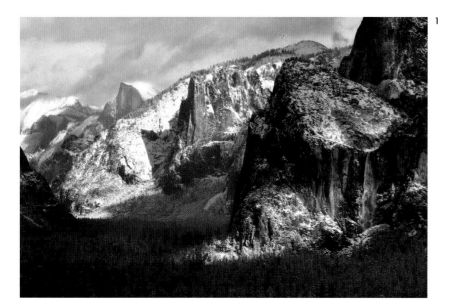

1

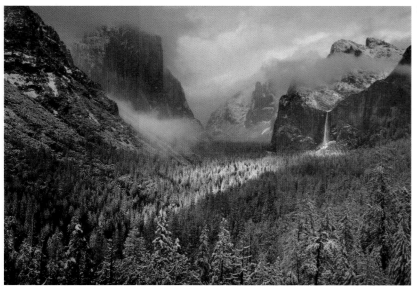

2

Paper Choice

Inkjet printers can produce beautiful images on almost any surface, including canvas, watercolor paper, and more traditional glossy and semi-gloss surfaces. Reacting to the soft-focus "pictorial" style of photography popular in the early 20th century, Ansel Adams and Edward Weston wanted to differentiate photography from other mediums, and advocated using smooth, glossy papers. Today, with photography firmly established as its own art form, the lines between photography and other art forms have become blurred, and any substrate can be an acceptable medium at the highest levels of photographic art.

The medium should match the message you're trying to convey. For an impressionistic look, by all means use canvas or watercolor paper. But if you want a more traditional photographic look then the crisp, clean look of glossy or semi-gloss (pearl, satin) papers will probably suit your style better and preserve more image detail and sharpness. Some of the newest inkjet papers bear an amazing resemblance to traditional black-and-white fiber-based papers.

3

1. Traditional Values

Classic landscapes lend themselves
to smooth papers with a traditional
photographic look and texture.

2. Proofing and Variations

The best calibrated monitor is no
substitute for making actual proofs
on the printer you'll be using for the
final output. After making a proof,
any changes you make to the image
should be applied to the master file.
The easiest way to do this is to print
proofs directly from the master file—
to send the master file to the printer
without flattening, sharpening, or
resampling it. It's possible to create
many variations of the master by
using layer groups in Photoshop,
virtual copies in Lightroom, or
versions in Aperture.

As with editing, time and distance
are vital. It's difficult to judge a print
immediately after pulling it from the
printer, but a week or month later its
flaws become obvious.

3. Soft Look, Soft Paper

Watercolor paper, rice paper, or canvas
might be appropriate surfaces for an
impressionistic high-key image like this.

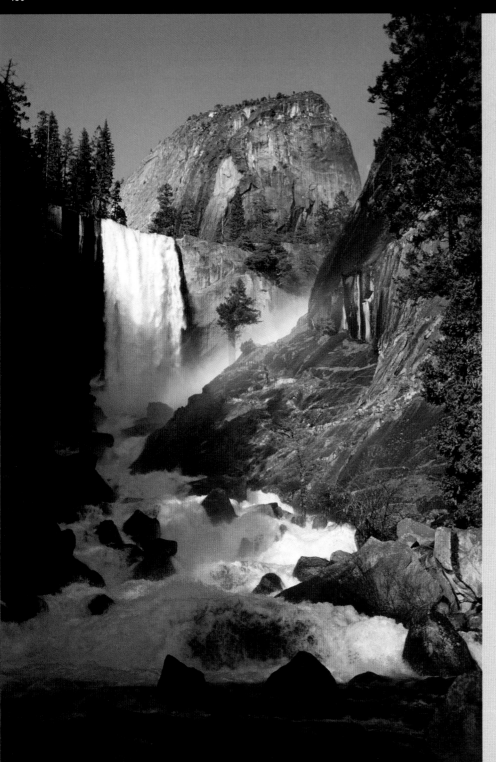

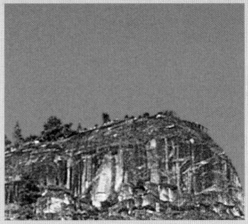

This image was captured with 35 mm film, so it has considerable grain. The upper enlarged section shows what happened when Photoshop's Unsharp Mask filter was applied to the whole image—the grain in the sky was sharpened and emphasized. Instead, I made a selection for the sky with the Magic Wand tool, inverted the selection and sharpened everything except the sky (lower detail and final).

Preparing the File for Final Output

After making proofs, a few essential steps still remain before making the final print. The specifics depend on the software and printer. The following steps apply to Photoshop. Even when I make a master file in a program like Lightroom or Aperture I usually open a copy in Photoshop to take advantage of its superior sharpening controls.

Make a copy of the Master File
If you made your master file in Photoshop, you don't want to flatten or resample the master. Make sure you've saved any changes to the master file, then select *File > Save As*. Choose a new name for the copy, and make all the following changes only on this copy, not on the master file.

Flatten the Layers
Layer > Flatten Image.

Resize
Since you're now working on a copy of the master file, it's okay to resample it—to change the number of pixels. In Photoshop go to *Image > Image Size*. Check Constrain Proportions and Resample Image. Set the print size in inches or centimeters, and select a resolution between 200 and 400 pixels per inch (ppi). Below 200 ppi the print may start to fall apart and become pixelated. There is no advantage to resolutions higher than 400 ppi, and no point in making the file larger than it needs to be.

Sharpen
In Photoshop use the Smart Sharpen or Unsharp Mask filters. Fine details like leaves, twigs, grasses, and the like can be enhanced by using a high Amount and low Radius with the Unsharp Mask filter. I typically use Amounts between 200 and 300, Radius settings between 0.3 and 0.5, and keep the Threshold at 0. If I want to avoid sharpening grain or noise in smooth areas like sky or water, I make a selection for those areas using any of the tools available in Photoshop (Magic Wand, Quick Selection, etc.), invert that selection, and save it as an alpha channel in the master file. Then, when I'm ready to sharpen a copy of that master file, I load the selection by ⌘-clicking (Mac) or Control-clicking (PC) the channel, then apply the Unsharp Mask filter.

Color Management and Printer Profiles

A printer profile translates the colors of the image to numbers that will look right on the printer. For example, Photoshop may describe a color as 80 red, 50 blue, and 120 green. The profile may need to send the numbers 90 red, 60 blue, and 105 green to the printer for that color to reproduce correctly—to match how it looks in Photoshop on a calibrated monitor.

Most printers come with their own profiles, installed with the driver software. How well these "canned" profiles work depends on the manufacturer's consistency. If all the same model printers are built to close tolerances (more likely with more expensive printers) then the same profile can work well for all the individual devices. If not, then you may have to make custom profiles for each paper you use. There are third party companies that make custom profiles, or you can purchase a software/hardware solution. You get what you pay for with these.

Managing Colors

1. Choosing Profile
2. Epson Color
3. HP Color

1. In most cases you're better off choosing the printer profile yourself. In Photoshop that means picking "Photoshop Manages Colors," and selecting the correct profile for the printer and paper. Either Perceptual or Relative Colorimetric are good choices for the rendering intent. Colorimetric may yield more saturated colors, but subtle gradations of tone in those saturated areas may be lost.

2 & 3. If you chose "Photoshop Manages Colors" you'll want to avoid having the printer software apply it's own profile or color adjustment. Each printer has it's own nomenclature; Epsons and Canon printers it is usually "No Color Adjustment;" while for HP printers it's usually "Application Managed Colors."

Lunar Eclipse Sequence

A calibrated monitor, precise printer profiles, and proper color management are essential for getting accurate color in digital prints.

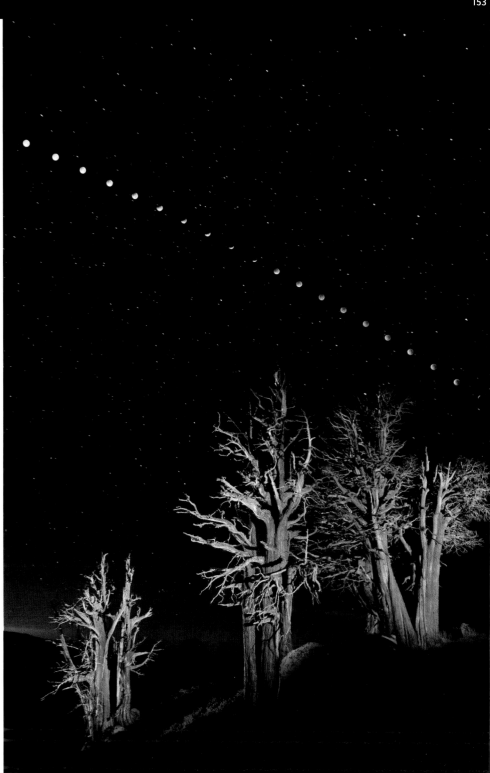

Black and White Settings

If your black-and-white image was captured in full color and then converted to black and white in software, your master file is still essentially a color RGB image with some instructions (either in the form of an adjustment layer in Photoshop or settings applied in a Raw processor) for the black-and-white conversion. When you copy this master file for printing, you can either keep it in RGB or convert it to Grayscale before sending it to the printer. The advantage of keeping it in RGB is that you can add an overall tint, but it's very difficult to add subtle toning reminiscent of traditional black-and-white prints this way—the tints are usually too strong, or not quite the right color. Some printers have options for tinting in the Print dialog, and these are often a better choice. You may also have an option for using only gray inks, which may not give you any toning options but may at least prevent your print from having an objectionable color cast. Special tinted ink sets are also available, but that locks you into the same tonal range for all your prints.

Toning Black-and-White Prints

Subtle toning of digital black-and-white prints is hard to achieve (and impossible to reproduce here). Inkjet printers designed for black-and-white output often have special settings for producing tints or neutral grays.

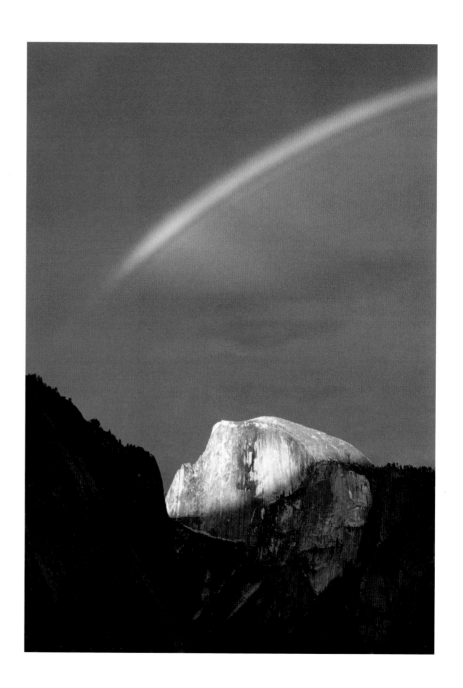

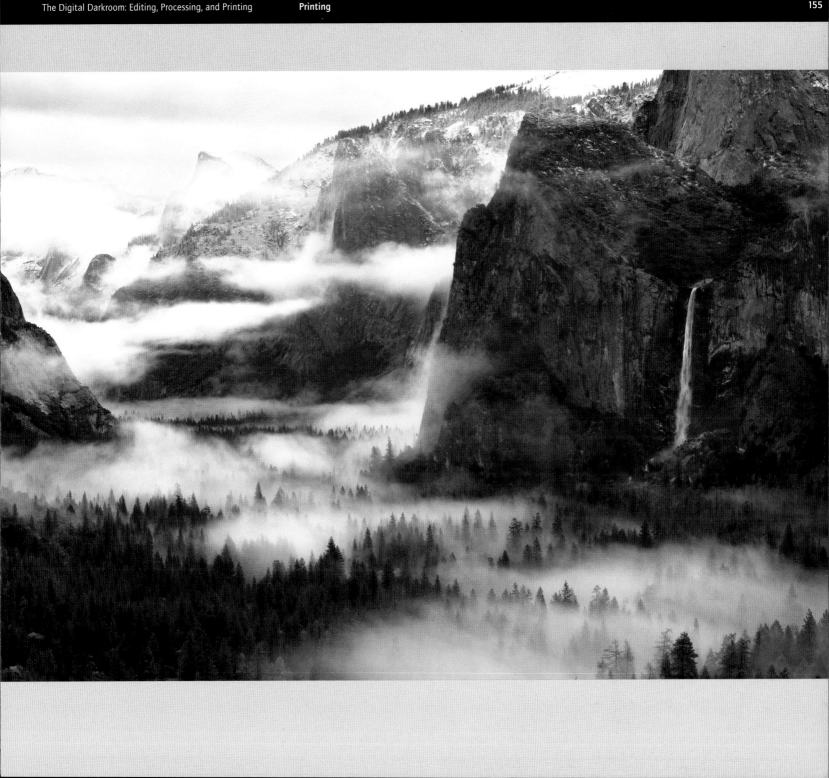

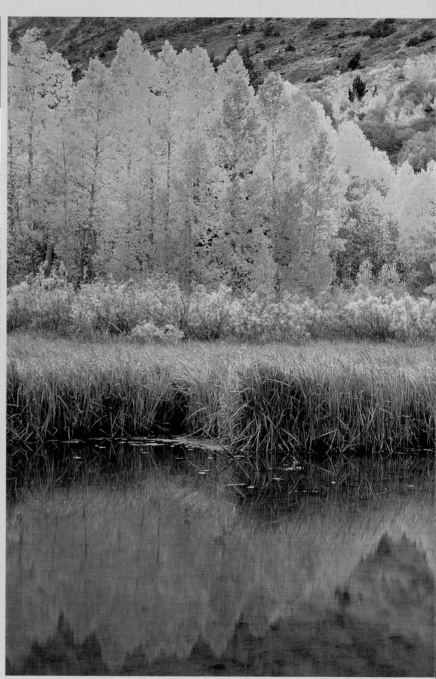

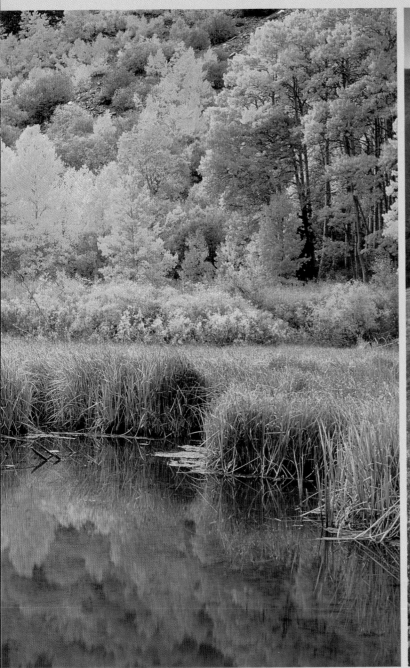

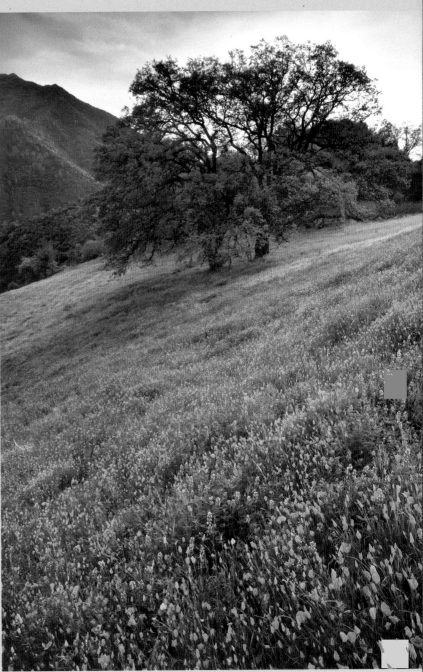

Picture Credits

Edward Weston Image, page 10
Dante's View, Death Valley, 1938
Photograph by Edward Weston
Collection Center for Creative Photography
©1981 Arizona Board of Regents

Eliot Porter Image, page 52
Eliot Porter, Pool in Mystery Canyon,
Lake Powell, Utah, 1964
Dye imbibition print (Kodak dye transfer)
© 1990 Amon Carter Museum, Fort Worth, Texas,
Bequest of the artist, P1990.51.5268.1
http://www.cartermuseum.org

Ansel Adams Images, pages 46, 68, and 102
© Ansel Adams Image Rights Trust / Corbis
www.corbis.com

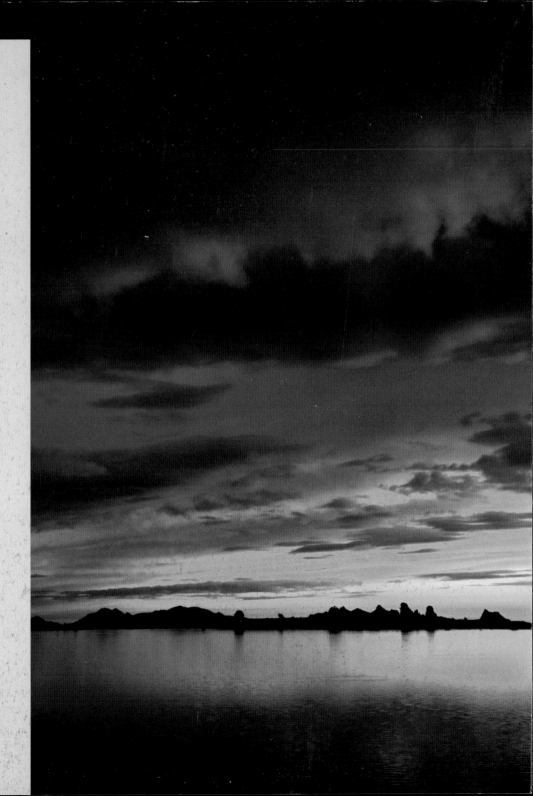

Neon Cat's Cradle

& 10 other string games

Licensed exclusively to Top That Publishing Ltd
Tide Mill Way, Woodbridge, Suffolk, IP12 1AP, UK
www.topthatpublishing.com
Copyright © 2016 Tide Mill Media
0 2 4 6 8 9 7 5 3 1
Manufactured in China

KU-592-239

TOP THAT™

Cat's Cradle is the most famous string game in the world!

String games and string figures have been around for thousands of years. They are played by both children and adults worldwide, and were originally created by ancient cultures for fun, storytelling, or magic. The Celts, Native Americans, the Inuit, and Aboriginal people are just a few who originated this string art.

Animal shapes and various symbols such as candles, diamonds, and even witches' brooms were created from pieces of string. Often the figures were used to tell a story or to bring good luck.

String games are as popular now as they were all those years ago. By learning how to make some of the string figures explained here, you'll help to keep this ancient tradition going.

It's fun to play on your own, but even better with friends. Once you've learned the basics, and made the figures in this book, you'll be able to create your own designs — and impress everyone. The kit even includes cool neon coloured strings to make sure your designs look great!

Getting Started

Whether you are creating string figures on your own (see pages 5 to 16) or playing string games with a friend (see pages 17 to 24), start by studying the HANDS & STRING diagram and guide on this page to learn what each finger and string is called.

To make each string figure or play each game, read the instructions and look at the pictures. Most of all, practise! Use your neon strings or an ordinary piece of string with the ends tied together.

When you're ready to play Cat's Cradle (page 17) and the other games, the instructions will talk about PERSON A (that's you), and PERSON B (the second player).

1. Little finger
2. Ring finger
3. Middle finger
4. Forefinger
5. Left forefinger noose
6. Thumb
7. Far little finger string
8. Near little finger strings
9. Far forefinger strings
10. Near forefinger strings
11. Far thumb strings
12. Near thumb string
13. Right little finger noose

Left hand　　　　Right hand

Position One & Opening A

Many string figures begin with Position One and Opening A. Learn to do these so you can make the Witch's Broom, the Cup & Saucer and other string figures on the following pages.

Position One

Loop the string across each palm and behind your thumbs and little fingers. That's it!

Opening A

Start with Position One. Then use your right forefinger to scoop under the palm string on your left hand (this means pick up the left palm string on the back of your right forefinger). Pull the loop out by separating your hands.

Now use your left forefinger to scoop under the palm string on your right hand (this means pick up the right palm string on the back of your left forefinger). Pull your hands apart to tighten the string. This is Opening A.

Position One

We have added colour to the 'action' parts of the strings.

Opening A

4

Witch's Broom

Here's a simple string figure to try solo — and remember, practise to make it work like magic!

1. Start by making Position One (as described opposite).

2. Use your right forefinger to pick up the left palm string, but don't pull on this string.

3. As your right hand moves back to its starting position, the forefinger moves away from your body and twists the right forefinger loop 360 degrees (in other words, twists it twice). Now pull your hands apart to tighten the string.

4. The left forefinger then moves right through the right forefinger loop, and picks up the right palm string (just like in Opening A).

5. Now release your right thumb and right little finger loops at the same time. Then pull your hands apart.

You've made a Witch's Broom!

Cup & Saucer

Flex your fingers and try out this cool string figure — the Cup & Saucer.

1. Begin by doing Opening A (as described on page 4).

2. Move both of your thumbs over the near forefinger strings and pick up both of the far forefinger strings. Pull your hands apart after each move to tighten the strings.

3. Now remove the lower of the two strings from both of your thumbs. (This is the string that was around your thumbs at the start.) You can remove the lower string from your thumbs by using your forefinger to scoop it, or use your mouth to take the strings off your thumbs.

4. Release your little fingers from the strings. Extend your thumbs and stretch your hands wide apart. Then tilt your hands away from you until you see the cup appear on top of the saucer!

Hold onto this — you're now going to make the Eiffel Tower out of it!

String Tip: If you stretch the Cup & Saucer out by bringing your thumbs and forefingers closer together (squashing the Cup & Saucer to make it long and thin), it becomes a **Boat on the Water**.

The Eiffel Tower is a famous landmark in Paris made from iron, but you can recreate it with string in no time!

1. Start with the Cup & Saucer.

2. Use your mouth to gently pull the middle of the near thumb string (the top of the cup). Pull it up, without releasing your thumbs, until you have made a big triangle. This big triangle shape is known as **The Witch's Hat**. The small forefinger loops are the brim of the hat. So that's another string figure to add to your collection!

3. To make the Eiffel Tower, remove your thumbs from the big triangle, so that the forefinger loops are larger and look like the base of the Eiffel Tower.

String Tip: Be careful when you make the Eiffel Tower, especially when you have the string of the top of the tower in your mouth. Don't let anyone pull it, even in fun, as it could catch in your teeth!

Butterfly

This is a pretty string figure for one person. Master it before you move on to Jacob's Ladder.

1. Begin by making Opening A (as described on page 4).

2. Release your thumbs from the strings.

3. Move your thumbs over the forefinger strings and use them to hook the near little finger strings.

4. Release the little
finger strings.

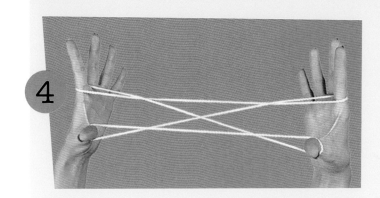

5. Hook your right thumb under
the first forefinger string
and pull it back towards you.

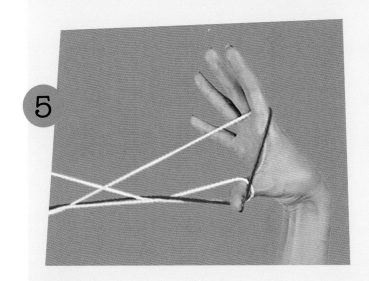

6. Using the thumb and forefinger
of your left hand, reach over to your
right hand and lift the lower thumb
string up and off the thumb.

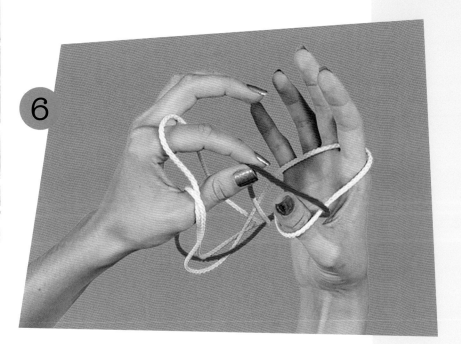

Now repeat steps
5 and 6 starting with
your left hand.

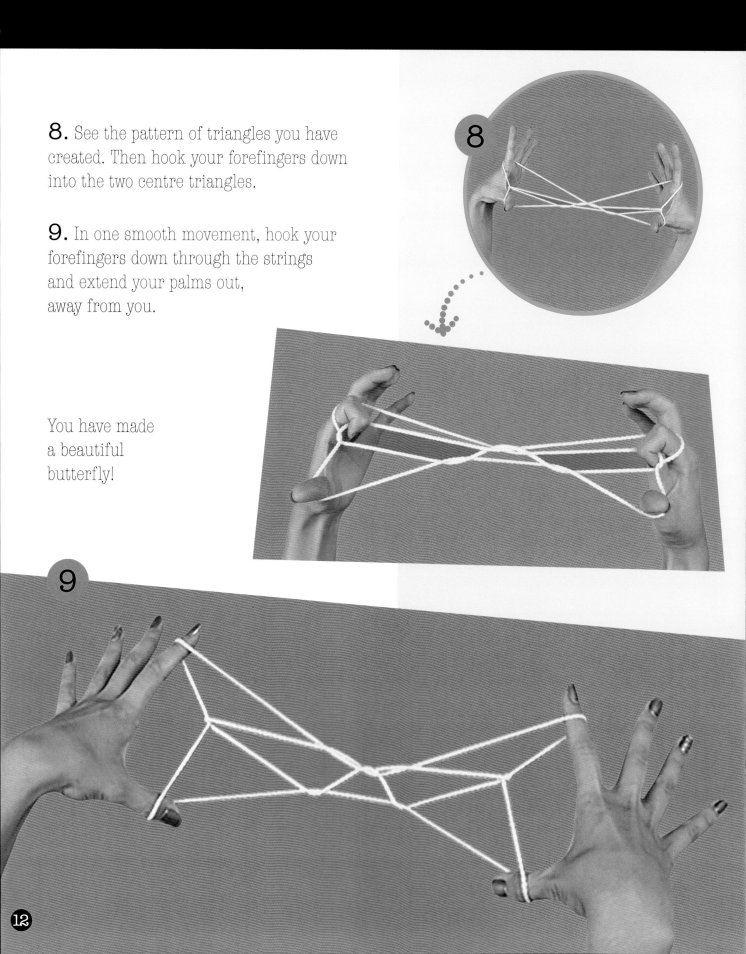

8. See the pattern of triangles you have created. Then hook your forefingers down into the two centre triangles.

9. In one smooth movement, hook your forefingers down through the strings and extend your palms out, away from you.

You have made a beautiful butterfly!

8

9

Jacob's Ladder

Jacob's Ladder can be tricky, but practice is the key! Master this before you move on to string games for two.

1. Make Opening A (as described on page 4).

2. Release your thumbs from the strings.

3. Pass your thumbs under all the strings and pick up the far little finger string. (Pick it up on the back of your thumbs.) Return your hands to their starting position with palms facing each other.

4. Pass your thumbs over the top of the strings and pick up the far forefinger strings. (Pick them up on the back of your thumbs.) Return to the starting position with palms facing each other.

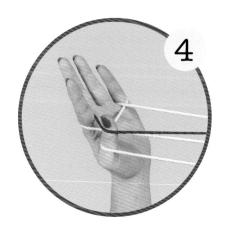

5. Release your little fingers.

6. Your little fingers then move over the near forefinger strings and pick up from below the far thumb strings. Return to the starting position.

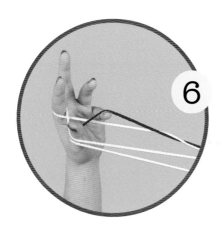

7. Release your thumbs.

8. Move your thumbs over both forefinger strings and pick up and return with the near little finger string.

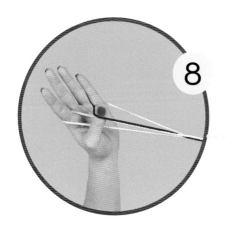

9. Use your right forefinger and thumb to pick up the left near forefinger string (from the back of the forefinger) and move it over the left thumb.

10. Again, use your right forefinger and thumb to pick up the lower near thumb string and move it to the far side of the thumb.

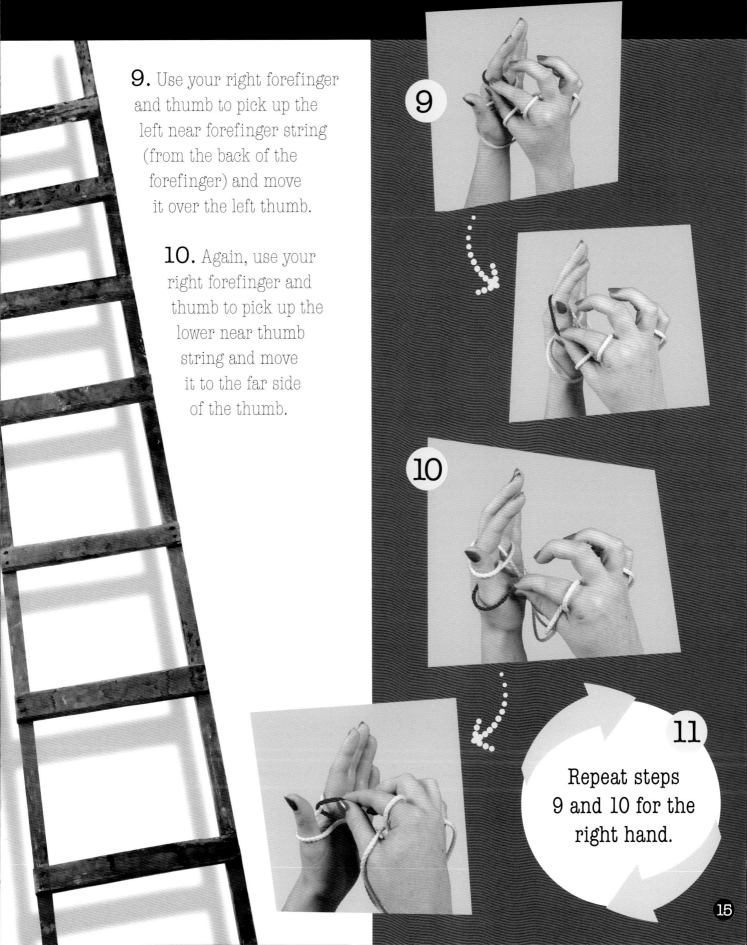

9

10

11

Repeat steps 9 and 10 for the right hand.

12.

12. Dip each of your forefingers into the small triangular spaces between your thumbs and forefingers. Relax your hands slightly to do this.

13

13. Then, releasing your little fingers, rotate your hands away from you, straighten your forefingers and extend the figure.

You've made Jacob's Ladder!

Now that you've mastered string figures for one, try the string games on the following pages.

Cat's Cradle

Are you ready to play Cat's Cradle? This starting figure is for Person A, but you will need a Person B for the other games.

1. Put the string around your hands, keeping your thumbs outside the string.

2. Loop the string around your hands. Start with your right hand, loop it through the top string — the one that's between your thumb and forefinger — and scoop it up onto the back of your hand. Repeat with the left hand. There should now be two strings across the back of your hands and single strings across your palms.

3. Use your right middle finger and put it through the left palm string (the loop on your left hand). After each move, pull your hands apart to keep the string fairly tight.

4. Use your left middle finger and put it through the right palm string (the loop on your right hand).

You have made the Cat's Cradle!

Hold onto this. Your friend is now going to take it and turn it into the Soldier's Bed.

Soldier's Bed

Now it's Person B's turn to make the Soldier's Bed from the Cat's Cradle.

5. Person B uses her thumbs and forefingers (moving from above your Cat's Cradle) and pinches the X-shaped parts of the two crossed strings.

6. While continuing to pinch the strings, Person B slowly pulls them away from the centre, until the string is taut.

7. Person B points her fingers down through the sides (the near and far straight strings), and then scoops them up through the middle.

8. Person B then pulls very slowly and gently, and gradually Person A lets the Cat's Cradle slide out of her fingers onto Person B's hands. Person B now has the Soldier's Bed on her hands!

Person B will hold onto the Soldier's Bed while you make Candles.

Candles

You are now ready to work with your partner to create Candles.

9. Use your thumbs and forefingers to pinch the side Xs. Pinch them from the top, not the sides.

10. Continue pinching the Xs and pull your hands apart slowly.

11. Still keeping hold of the Xs, push your fingers up through the centre.

12. Finally, pull your fingers up and take the strings onto your hands.

You have made Candles!

Hold onto the Candles because it's now your friend's turn to take them from you and create The Manger.

The Manger

Person B performs this part of the string game.

13. Person B hooks her little finger over the near forefinger string and pulls it over.

14. Person B then hooks her other little finger over the far thumb string and pulls it over the other side.

15. Do this next part slowly — it's a bit tricky! Person B keeps the triangles at her little fingers taut and turns her hands and points her thumbs and forefingers down into the triangles.

16. While continuing to hook the ends of the triangle with her little fingers, Person B then dips her thumbs and forefingers down into the triangles and scoops up (using her thumbs and forefingers) inside the centre of the whole string shape.

17. Person B should still have a taut grip on the strings with her little fingers. Then she spreads her thumbs and forefingers apart, while also pulling her hands apart. This creates The Manger. (The Manger is an inverted Cat's Cradle.)

18. To finish, Person B turns her hands up to her face to see The Manger side on.

You are now going to take The Manger and transform it into Diamonds!

Diamonds

Flex your fingers and get
ready to make Diamonds
from The Manger.

19. You (Person A) begin by pinching
the Xs (where the strings cross).
Pinch them from the outside using
your thumbs and forefingers.

20. Gently pull
the strings apart.
Pull them away from
the outside strings.
Then pull them up.

21. Keep pinching the Xs, then turn your hands and point your thumbs and forefingers down through the centre of the strings.

22. Finally, pull your hands apart, spreading your thumbs and forefingers apart at the same time. (Your partner releases her hands as you do this.)

See the great Diamonds you have made! (Diamonds is an upside-down Soldier's Bed.)

Now it's your friend's turn to make the Diamonds into the Cat's Eye.

Cat's Eye

Person B completes this string game by making the Cat's Eye from the Diamonds.

23. Person B pinches the Xs with her thumbs and forefingers.

24. Then Person B pulls the Xs out over the other strings and points her thumbs and forefingers down.

25. Person B scoops her thumbs and forefingers under the other strings, then up through the centre, taking the strings from Person A.

26. Person B spreads her fingers apart to make the Cat's Eye.

The game is complete!

String Tip: To get really good at different two-player string figures, take it in turns to be Person A and Person B. You'll be a pro duo in no time!